LIFE AS
A VISITOR

*"Where we had thought to travel outward,
we will come to the center of our own existence.
And where we had thought to be alone,
we will be with all the world."*

Joseph Campbell

© 2009 Assouline Publishing
601 West 26th Street, 18th floor
New York, NY 10001, USA
Tel.: 212 989-6810 Fax: 212 647-0005
www.assouline.com
ISBN : 978 2 7594 0407 0
Printed in China.

For David, Phillip, and Eli

LIFE AS A VISITOR

ANGELLA M. NAZARIAN

ASSOULINE

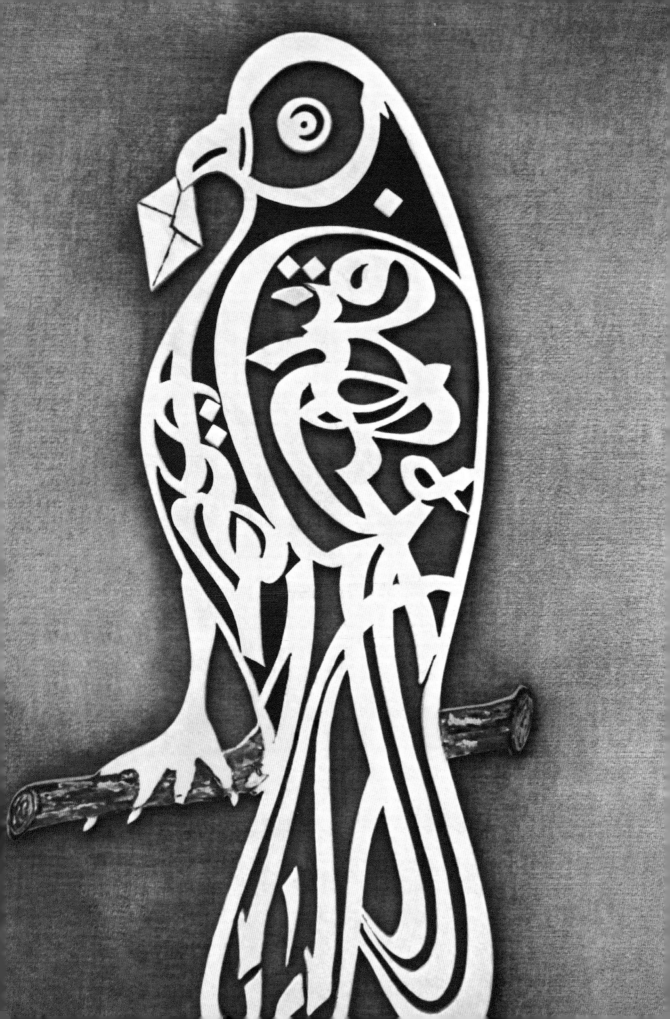

Contents

Opposite: Calligraphy, such as the bird at left, is one of the most celebrated forms of art in Iran. The movement of the line captures a poetic impulse that is in tune with the spiritual.

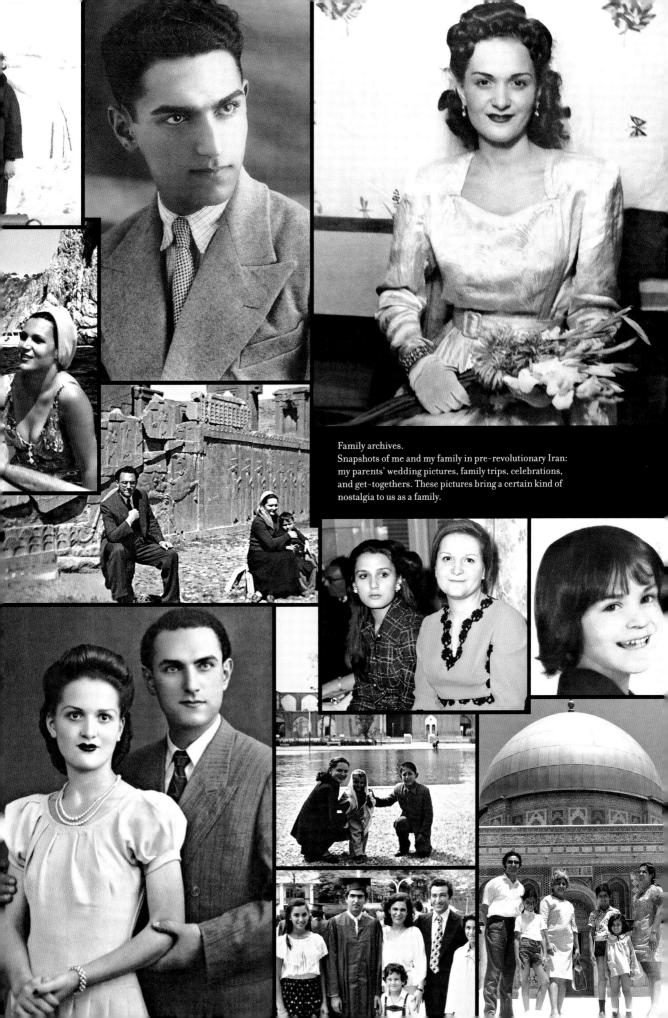

Family archives.
Snapshots of me and my family in pre-revolutionary Iran: my parents' wedding pictures, family trips, celebrations, and get-togethers. These pictures bring a certain kind of nostalgia to us as a family.

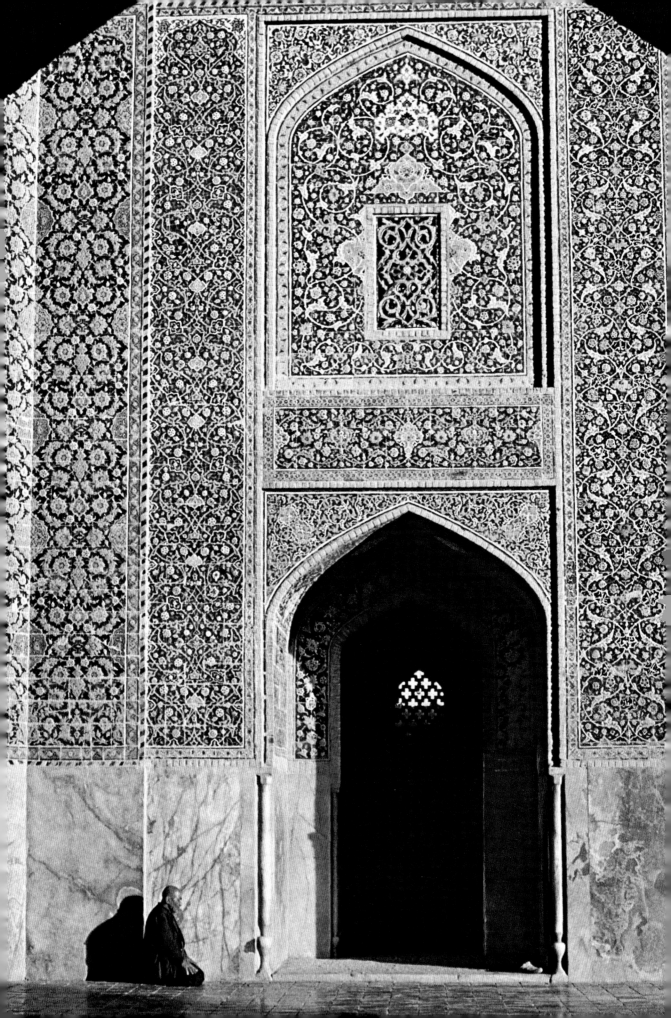

Preface

 I remember being three years old, standing on an ornately carved chair in our living room in Tehran. What I really wanted, back then, was to get closer to a freestanding glass cabinet that encased the most unusual porcelain doll I had ever seen. It was a flamenco dancer—black hair done up in a bun with a rose tucked behind her ear. I had never seen anything like her. Her face was turned to the side, showing a striking profile, while a pair of castanets dangled in her hands, held high above her head, and ruffles upon ruffles of red polka-dotted skirt cascaded from her hips.

Right below that shelf was a handblown glass gondolier, standing in his thin boat with a smart black-and-white-striped shirt and wide-brimmed hat. I wanted so much to touch and play with these souvenirs that my parents had brought home from their faraway travels. But the cabinet was locked and the keys put away.

While standing on that chair, I heard my mom's voice calling, asking me to come downstairs. I wrapped my hands tightly around the banister and took very cautious steps, as I was scared of tumbling down those steep stairs. Once I came to the front hall, I saw my siblings all seated around a table. They motioned me to take a seat in front of a frosted cake lit with candles. I put my knees on the seat of the chair so I could see over the tabletop.

Everyone started singing "Tavalod," the traditional Farsi birthday song. I joined in. And when the song ended, everyone looked at me in anticipation. But not knowing what to do, I simply played with the pom-pom tassels of my knit dress. Everyone broke out in laughter.

"Come on, Angella," my mom said.

Come on what? I wasn't sure what I was supposed to do, and looked around at the faces of the grown-ups to get an idea of what should happen next.

Then my brother Kourosh yelled out from across the table, "It's your birthday, Angella! Blow out the candles."

And so I did, and a wave of applause followed. I was just relieved that I had taken the cue.

* * *

I can only surmise why this two-part incident has crystallized in my mind, but it speaks volumes about who I am. While some little girls are drawn to the familiar, I have always been struck by the exotic—that beautiful Spanish flamenco dancer or the prim Venetian gondolier. I have always been drawn to worldly adventures. These journeys have been the best vehicle for my own self-discovery, and my attempts to define my unique identity as an Iranian Jewish American woman.

I have always found myself in between worlds. Thanks to my sudden immigration to the United States at the impressionable age of eleven, a childhood sense of "placelessness" has brought forth an ever-present feeling that I call "a longing to belong"—to find a home.

> *I have always been drawn to worldly adventures.*
> *These journeys have been the best vehicle for my own self-discovery.*

Once we immigrated to a predominantly Jewish community in Beverly Hills, California, we were different because we were Iranian. And now, having lived in the States for thirty years, I no longer define myself only as a Jewish woman of Iranian descent; I am also an American. The members of my generation are the first to be identified this way, and it is both a privilege and a burden to define a new identity for ourselves. I have had to figure out which elements of my traditional Eastern culture I want to keep and which aspects of Western culture I would like to incorporate into my value system. This has been no easy task. Although it may seem as if I have been treading a defined path, in reality I have spent much of my energy figuring out if I am doing the "right" thing. To some degree, this is part of everyone's growth—to find one's real self, the one not rooted solely in social and cultural norms.

Travel has no doubt helped me figure out some of these issues. I may be what you call a permanent tourist—no longer living beneath the sky under which I was born, but always on a quest or a journey. After visiting more than fifty countries on every continent but one (I passed

Preceding: Shrine in the main court of the Masjid-i-Shah in Isfahan. Tilework was the most important decorative feature of Iranian architecture. *Opposite:* Lattice framed with tiles, from Gur-Amir, the tomb of Timur, c. 1404.

on Antarctica because I get seasick), I have seen a truly wide spectrum of lifestyles up close. These experiences have helped me develop more compassion for differences that exist among people, while at the same time affirming my own idiosyncratic tastes. I also have had the great fortune of exploring a slice of my own history and past against various backdrops, from Jordan to Jerusalem, from Istanbul to Italy, from Chile to Cambodia.

So, it is in the spirit of this self-discovery that I have crafted this memoir to explore the vanishing details of my past and my changing identity in the context of my travel experiences. Throughout the book, there are two parallel narratives: My family's high-stakes escape from revolutionary Iran, and our ensuing adjustments in the New World. The latter narrative, which often takes the form of verse, draws on my travels and touches on how a similar theme or experience has a way of collapsing the distance between past and present, here and there. As I followed the migration of the wildebeests in Kenya, memories of my own family's immigration resurfaced. And when caught in political upheaval in Argentina, I reflected on my childhood experiences in revolutionary Iran. This impressionistic format, with prose and poems, best captures the fluidity in my development as a person, which is often nonlinear but interrelated.

Nowadays I no longer feel like a perennial outsider. What I have learned, and what I hope to share, is that we can, indeed, all find common ground no matter where we come from. In my most inspired moments, everything I look at, no matter where I am, has the familiarity of home; it's as if somehow my sense of placelessness transforms into a more inclusive and expansive state—one of boundlessness. In the end, my own definition of who I am has changed. I belong not only to a particular geographic, religious, or ethnic group, but also to a vast and often complicated tapestry of human diversity. I am no diplomat, of course, nor even a goodwill ambassador: I'm just a girl who was born on one side of this earth and raised on the other, who has managed to spend lots of time trying to figure out what's in between.

> *We are of the heavens, and heavenward we go,*
> *We are of the sea, and seaward we go,*
> *We are not of here nor there,*
> *We are placeless and to the placeless we go*
> —Rumi, thirteenth-century Persian poet

Opposite: Me at home in Bel Air. *Following:* A woman in the bazaar in Rasht.
This picture was taken in the early 1970s when my cousin Mitra visited Rasht, my father's birthplace.

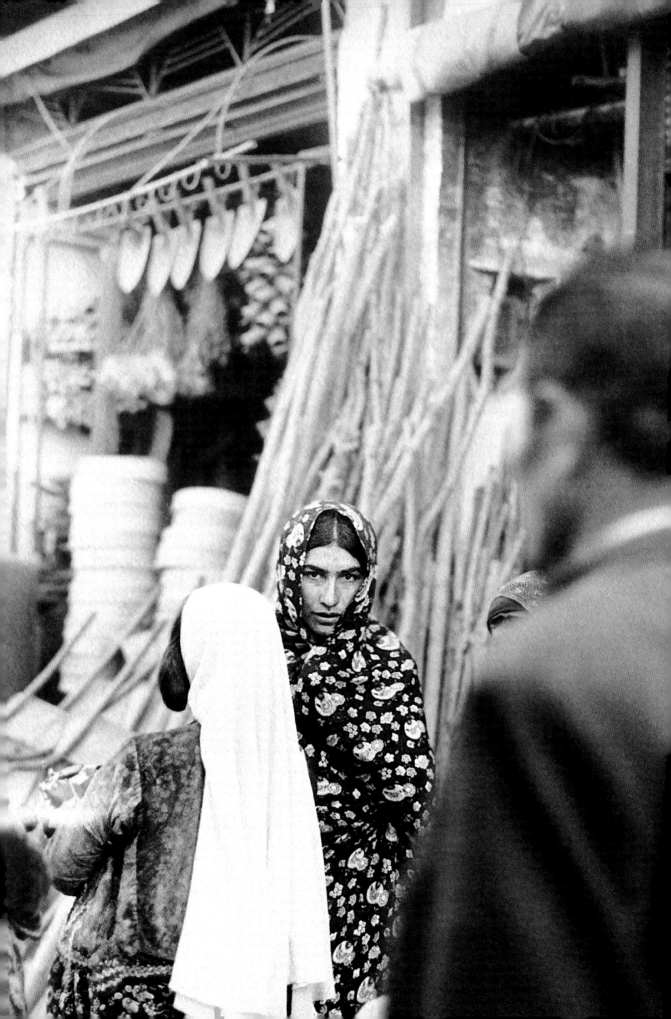

A Tale of Escape

For some, a journey is nothing but bliss. New scents, new scenes, new sensations. Exotic passport stamps are badges of honor. You collect them like kids collect coins.

Yes, all journeys wind their way through difficult terrain. But for me, even a family vacation can bring back more complex feelings and images. One never really knows why—the mind works in wondrous ways. But I think I have an idea.

My parents, who grew up in Iran, were well traveled—Bombay, Nice, Osaka, Hamburg. But these are not the trips that I want to tell you about. It was their last trip out of Iran—to America—that changed our lives. It was a passage, mostly at night, that was fraught with fear. The landscape was barren. Their guides were smugglers. The risk was enormous. This is a part of their lives that only my parents carry with them. Simply put, almost twenty-five years later, they can hardly even talk about it. Recounting this drama inevitably pierces the gloom and fear of the past. And unlike the home, the belongings, the friends, and the family they left behind in their disinherited country, my parents prefer to forget about a time and place that was filled with many hardships.

Much of my understanding of what happened to them comes from piecing together years of halting conversations in Farsi with my mom. These memories are now part of the family legacy. This is not a tale of politics; I'll leave those specifics to others. But this was a difficult time. Revolutions are not easy on any family. Mine was no exception. Our family was split. My beloved uncle, a high-ranking official

in the government, was locked away in the infamous Evin prison in Tehran. The charges were trumped up, but in the postrevolution chaos of the eighties, that hardly mattered. My grandparents were aging. My widowed aunt was struggling. And my brothers and sisters and I had already been sent to safety in California.

My mom and dad were stuck. Half of their relatives were in Iran; the others were in the New World. Our assets, like those of everyone else who tried to flee, presented a whole other set of problems. So that was our situation in late November of 1983.

> ❝ *The landscape was barren. Their guides were smugglers. The risk was enormous.* ❞

As Mom tells it now, the escape began at five in the morning, when the smuggler pulled up at their home in a nondescript Paykan, the ubiquitous vehicle of choice for most working-class families. He was a young guy, dark, with close-cropped curly hair. My parents were scared.

They had already shelled out more than half a million Iranian *toman*—about $100,000. But there were few other choices. The government had cracked down on anyone trying to transfer assets out of Iran. The climate for Jews there was becoming more hostile. They were trapped—and cut off from their children.

The original plan called for them to make a two-day drive with this young smuggler. In the dead of night, they would drive to Zahedan and stay there until daybreak. They would then drive several hours more through Taftan, a mountainous area in southeast Iran close to Pakistan, where they would sneak across the border. They would meet the smuggler's wife at the Hilton hotel in Karachi, Pakistan. She was to give them some cash, gold coins, and jewelry, which my parents had slipped to the smuggler in advance. Because they had left everything else in Tehran, this would be all they had to finish the trip.

Mom, who was wearing the mandatory chador on her head, packed only a skirt and two shirts in her small bag. They didn't want to arouse suspicion. The trip started well. They thought they had done the right thing.

"Relax, lady," the young smuggler told my mom. "We do this all the time. It will take just a couple hours to get to Zahedan. There you can rest. Just say you are my cousin when we get to the checkpoints."

Their ruse was successful. And although the remainder of the trip would be seven hours, they were relieved when they arrived at the border town. But alas, it was not that simple. They were supposed to meet a hajji at the border to facilitate their crossing. A hajji is a religious man who is given much respect because he has made the pilgrimage to Mecca.

But Mom and Dad were late—very late—because the smuggler had told the hajji they would be arriving a day earlier. "I'm sorry. I don't think I can do anything today," the hajji said when he met them. "You should have shown up days earlier. This is not good." The smuggler was panicked and sweaty. Mom and Dad were frightened.

After a lengthy back-and-forth, the hajji agreed to hide them—first in his modest home, later moving them around to other safe houses. "Let me see if I can find someone to take you across," he said. Eventually he did. They heard a knock on the door of their safe house. "Get out of here. Let's go," said an unfamiliar voice.

All three—my parents with a new smuggler—sat in the front of a van as they drove off with no lights. The roads were dirt. The sky was black. Mom was terrified.

They stopped once or twice to pick up strange passengers who jumped in and hid under blankets in the backseat. One was said to be their guide, who knew the isolated mountain roads and could direct them to the border.

"You don't want to turn on the headlights?" my mom asked, fearing they would tip over on one of the hairpin curves of the mountainous roads.

"No. Us Baluch men all have keen eyesight," he said. "We can drive in the night with no lights. Besides, it's too dangerous."

This part of the trip was supposed to take an hour. Mom and Dad were suspicious. They had heard stories of others who had been raped, mugged, abandoned—even killed—by these Baluch men.

"No worries, no worries. A half hour more." Actually, once they crossed the border, it took seven.

The crossing itself was uneventful. They forked over a bribe to the border patrol and breezed into Pakistan. The rest of the drive through the arid landscape seemed endless. But eventually they arrived in Karachi and relief eased in. The smuggler took them to a chain hotel, where they checked in, showered, and changed clothes. Mom remembers that she even smiled and had a nice dinner. They strolled in the streets. They were sure they had done the right thing.

The next day, they set out in a cab to meet the smuggler's wife.

"Can you take us to the Hilton hotel?" my dad asked.

"Hilton?" the taxi driver said. "We have no Hilton." They had been had—and were stranded in a strange land with no more than a day's pocket change.

More important, though, they had no visa. And they were alone.

* * *

Their first task was to figure out how to get some money. Somehow they were able to call us in Los Angeles and had my brother wire enough funds so they could try to make travel arrangements. This, however, was not so easy.

They had originally planned to fly to Madrid, because Spain was the only country to which an Iranian citizen could fly without needing a visa. But, unbelievable as this may seem, that regulation changed the very day they arrived in Pakistan. Now even a trip to Spain required paperwork and documentation that was impossible for them to come by.

Their luck changed a bit, however, and a travel agent—actually, he turned out to be a travel angel—befriended them after seeing my mother crying in his office. He took them out to dinner and agreed to help. He also cautioned them to keep a low profile, stay off the street, dress like the Pakistani people, and be very circumspect. This town, it seems, was filled with illegal immigrants from Iran, and the Pakistani police were rounding them up, extracting bribes, and threatening them with expulsion.

My mother remembers this travel agent well, of course. Twenty-five years later, she still has his business card. His name was Sayed Anwar Hossain, but his nickname was Mr. Rafig. In Farsi, *rafig* means "friend."

After much back-and-forth, Mr. Rafig was able to secure them tickets to Paris. They were set to leave on a plane with twenty-five other immigrants. But at the airport, the first of many travel problems surfaced. Whenever the Pakistani airport authorities called out the names of these would-be passengers to Paris, no one responded. It seems they all had forged passports with phony names they did not even remember.

Eventually, the flight took off from Pakistan and landed at Charles de Gaulle. My parents thought they would be safe and soon on their way to America. But it was not to be.

As soon as they disembarked the plane and entered the terminal, all the Iranian passengers were detained by armed guards and ushered to a holding cell. "Why?" asked my father, the only member of the group who spoke fluent French.

"We're sending you back on the next plane to Pakistan," he was told.

My father pleaded with the authorities. "Couldn't we at least wait until the morning? Maybe by then you can figure out where we can go." The French guards agreed and the travelers spent the night in limbo in a dingy hallway. There were three chairs and no food. The police even escorted them to the bathrooms. Many of the passengers were nothing less than hysterical.

Following: Stone sculpture of an old man in France. On my visit there,
I came upon this sculpture, and it reminded me of my father.

The passengers were rounded up the next day and dispatched to a new gate. They were told they were headed off to Zurich. This seemed to satisfy everyone. One by one, they filed past the security guards. Finally my father approached the gate.

"Where are we going?" my father asked the agent, double-checking in a matter-of-fact tone.

"Back to Pakistan," he was told.

My father was always known as a fast thinker and a resilient man. His response was immediate and firm.

"No. We're having a sit-in." He turned to the other passengers and exposed the plot. He told everyone (in Farsi) to sit down and resist.

"We're not leaving. We're not moving," he said. "Find a country." More agents and French guards arrived.

My father's plan worked. Somehow, some way, arrangements were made to let the wayward Iranians continue on to Portugal. As long as they left Paris, the French did not care.

Until the day he died, Paris remained my father's favorite city in the world. But this scene at the airport was how he saw Paris for the last time.

After their ordeal at Charles de Gaulle, the flight to Lisbon was uneventful. My mother and father remained there for a month until they were able to secure documents that let them travel to Israel. From there, they made the plans that led to their eventual immigration to the United States.

The family ties pulling my mother and father to America were strong. But so, too, were the family ties holding them back in Iran. Politics made matters even worse. It was a trying period for all of us. But my scattered family finally came together.

This was not the journey they had ever planned. Nor was it the one that their children had expected. But it got them here nonetheless.

To make a trip like this, you need an element of faith.

Paris—My Last Father's Day Present

The steps I took,
one and one
after the other one,
through crowded Paris streets,
*were a gift to **him**, my **father***
with the brilliant eyes and silver hair.
The month before,
he'd told me, sitting on his favorite chair,
of his love for Paris and his wish to see it again.
He let out a long sigh and fell into a distant gaze
*I **knew**,*
we both knew
he was alive on some kind of loan.
We knew of the season's ticking away,
we knew of the falling of the leaves and
*the migration of **silver-winged birds.***

When I went to Paris to live out his wish,
I followed the path my father knew so well.

I moved on, ahead,
the way my father forged ahead
rooting himself to solid ground,
feeling the weight of the firm, dark earth
*press against his **measured steps.***
For my father,
I put one foot in front of the other,
one-two staccato steps,
and marched through winding, cobblestoned streets
near the River Seine.
For my father,
I climbed up the hills of Montmartre,
watched the clutter of rooftops against the pale blue sky,
and reached for a pocketful of clouds

to bring home as a souvenir.
For my father,
I went to visit Versailles
and treated my eyes to extra helpings of marble and gilt.
For my father, I found a jewel-like sidewalk café,
drank glasses of musky, golden wine
and had morel mushrooms fit for two.
I threw caution to the wind and walked
until the sun flashed purple on limestone walls. Then,
when I paused to sit,
thoughts of my mother came to mind.
My mother, delicate and luminous in transparent skin,
who spent a locked-out, cramped-in detention day
in the Paris airport,
my mother, who couldn't and wouldn't set eyes
on this city again.
For her,
I closed my eyes when darkness fell,
and swept up stray thoughts
of the **migration of birds** under my bed.
Instead the next day
I moved on, ahead,
heard the clatter of my steps,
against cold, wide stone,
and went in search of bistros with cracked-leather seats
and had me a fix of the darkest of chocolate mousse,
this time fit for three.

When I came home to see my father,
outside I heard the distant clamor of
silver-winged birds.
My father shuffled in to greet me at the door,
his gait weighed down by the things left undone.

He talked about philosophy and Napoleon through
sips of steaming herbal tea.
That's how I remember him,
my father seated in his favorite chair,
the afternoon light streaming in from behind,
highlighting his **wild silver hair.**
We wove in and out of French and Farsi through sips of tea.
I nodded and put on a schoolgirl smile,
my fingers prodding the sharp edge
of my last Father's Day gift.
I nodded and smiled, while sinking inside,
thinking about the stirring of the wind
and the falling of the leaves.

I took his hand in both of mine
and placed the pictures of the trip
in the palm of his hand.
I never loved that man more
than when I watched his mouth curve in delight,
at the sight of the shapes of the world
he longed to see.

While he talked, I looked out
and saw birds circling above, flapping their wings.
I felt myself move without a thought
forward into him.
I closed my eyes for a second or two,
took a deep breath and held it in.

I wanted to store my father's faint scent in my lungs,
like the pictures I'd saved
to remember things gone by.

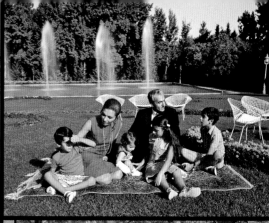

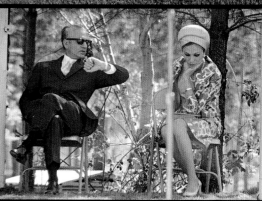

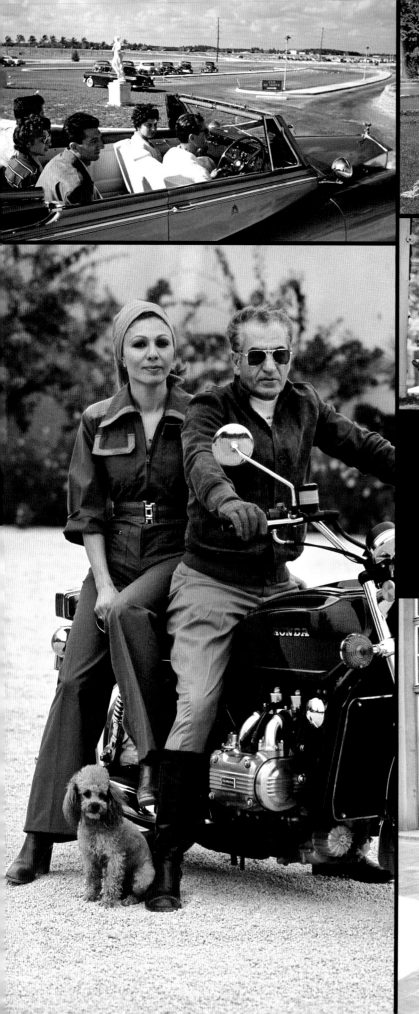

Clockwise from top left: Mohamed Reza, shah of Iran, and his second wife, Queen Soraya, on holiday in Miami Beach, 1955; with his third wife, the Empress Farah, and their children Prince Reza, Princess Farahnaz, Prince Ali Reza, and Princess Leila; awaiting the start of a parade in Tehran, 1971; relaxing with the newspaper, summer 1955; vacationing in the Ile de Kish on a motorbike, March 1977. *Opposite*: the shah on his gem-encrusted throne, 1968.

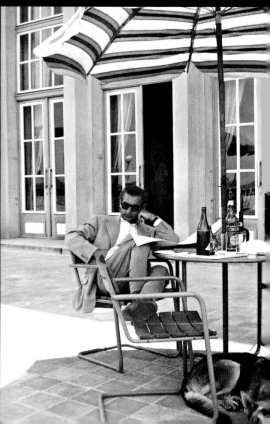

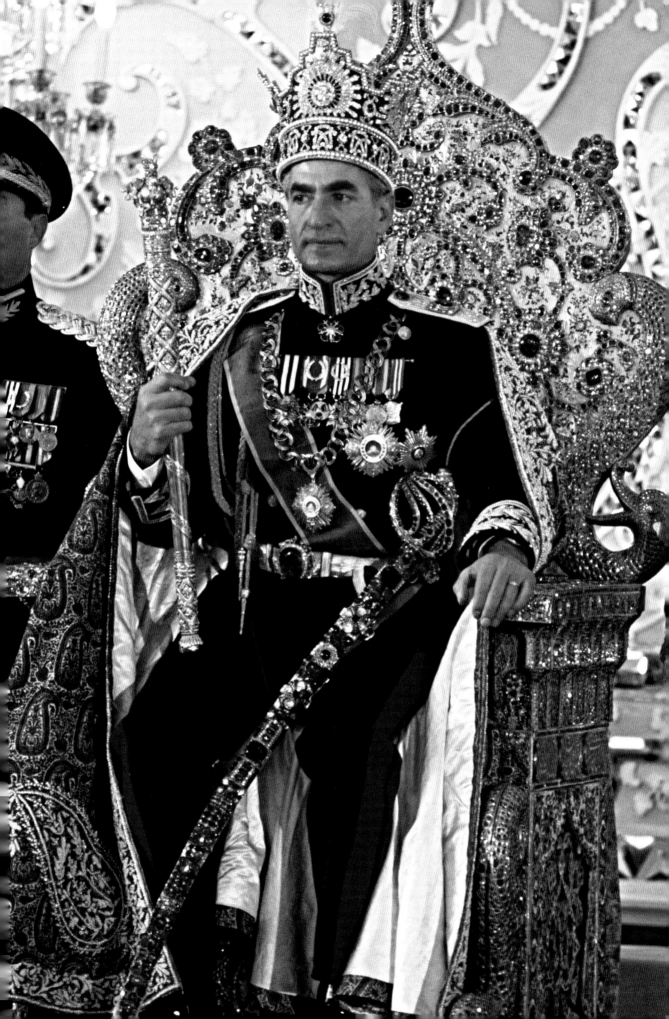

A Childhood Cocoon

I lived the first eleven years of my life in Tehran, Iran. It was a cocoon. My summers were spent (much to the dismay of my mother) running barefoot around the house. I loved swimming in the pool and buying chocolate popsicles from the ice cream man who passed through our neighborhood on his moped every afternoon at three.

It was here in the streets that I got my first glimpse of the outside world. Once a month, in the afternoons, a man would walk though our neighborhood with a giant tin box on his back. He would call out, "*Shahre farang . . . Shahre farang*!" (Foreign land!)

As he cried out, children from all over—including me—would race to his side to peek inside his mysterious box. The kids pushed and shoved to try to be first in line. If we gave him a coin, he would let us peer through the two holes that were cut in his box. What we saw inside was amazing. There were colorful slides of the Egyptian pyramids, magical castles in Germany, the ornate Big Ben clock tower in London, and the graceful Statue of Liberty.

As a child, you always think that life is confined to the radius of your neighborhood and your school. For me, this large tin box was a window into the vastness of our planet. Where exactly were these fantasy castles? Just how big was that giant clock? Could I one day see that lady holding that torch? I knew that my parents had seen all these things. I always hoped that it would be my turn someday.

Although I was born into a large family, with three older brothers and an older sister, I spent most of my days playing alone or with Kourosh, my brother who was five years older. My oldest brother, Jamshid, was hailed as the

genius of the family. He was eighteen years old, had skipped a grade in school, and was already in his second year of studies at Tehran University by the time I was born.

When I was young, I had a secret crush on him. In many ways he served as a surrogate father—taking me to the movies, helping me with my homework, and taking a keen interest if I had bought new clothes. I would wait by the entry stairs of our house every afternoon to catch him coming home from the university. Jamshid left to finish his medical internship in the States when I turned seven. It was my first sense of loss. I missed him terribly.

My sister, Lida, smart, sassy, and independent, was fifteen years older than I. She got married when I was five and left to live with her husband, who was finishing up medical studies in Germany. My only memories of her, before she left, were the times I sneaked into her room and marched around the hallways in her multicolored, metallic platform shoes. What fun for a four-year-old!

Dariush, my other brother, was ten years older than I. He was the most popular kid on the block, always busy with friends and music. On any given day he would be sampling and blasting the latest Top 40 hits in the house—Eric Clapton's "I Shot the Sheriff" or Barry White's "Never, Never Gonna Give Ya Up."

My father was not amused. He would come home from work and bang on Dariush's door, complaining that the blaring sound was vibrating our crystal chandeliers. Dariush was the only child in the family who ignored my father's stern manner.

My father was a towering figure of discipline, demanding our respect. Whenever he came home, we actually stood up to greet him. He had no patience for childish chatter or frivolous things. At the dinner table, we waited for him to address us before speaking to him. When he took his midday nap, the house fell silent. On some level we were scared of him, but even more so, we held him in deep admiration. This is why we all tried so hard to win his affection by being model students at school. He worked hard and expected us to do the same in school. He always told us, "If I hadn't had to start working at such a young age to support my own family, I would have studied to become a doctor." Instead, he became a businessman, importing tools from Eastern Europe and China. It was a lucrative profession, but not one that he had real passion for. It was no coincidence, however, that Jamshid became a doctor, that Lida married one, and that Kourosh and I had thought of studying medicine, though it was never expected of me—a girl—to have such high aspirations. As for Dariush, he had the good sense to have a rebellious streak at an early age and set himself apart by treading his own path.

The highlight of my summers was making a four-hour winding trek through the Alborz

Preceding: A miniature by Mou'in, representing perhaps a marriage feast with musicians and servants.
Opposite: My cousins, standing in a courtyard in Isfahan, renowned for its ancient Persian architecture and monuments.

Mountains to Shomal and the beach towns by the Caspian Sea. I spent hours in the sand, watching the white water surging at my feet, dreaming of what lay on the other side of the sea. Although my father was a quiet man, the sea opened him up to the many memories he had of growing up in Rasht, a port town on the northern coast of Iran. At times, while eating at one of the seaside restaurants, he would recount how he swam upstream when he was young and athletic and how, at the age of ten, he would sneak into theaters and watch late-night movies. I could never imagine my father so carefree, and the thought of him sneaking out of the house was as unbelievable as Dariush becoming a studious nerd.

Rasht, a major trading center between Iran and Russia, was a lovely coastal town nestled in the slopes of the Alborz mountain range. Papa talked about how he was fascinated by Russia, just across the water, and how its ominous presence was always felt in their town. When he was six years old, he saw Bolshevik soldiers, with big silver buckles tightly fastened on their gray uniforms, march through the streets of Rasht and set fire to the shops and the storage houses by the port.

"They thought they could annex the northern part of Iran, but at the end they couldn't," he used to say with pride. "Iran has always been on the brink of foreign occupation and internal threats. I even remember when the famous revolutionary leader [Mohammad] Mossadegh wanted to overthrow the government, but what people don't know is that this country always comes out on top." Whereas others may have been unnerved by uprisings and unrest, my father's experiences with political turmoil may have hardened him a bit. This cool head helped him prevail in later years.

We traveled to the Caspian Sea every summer, and inevitably I would hear the same stories, year after year, as if the sea's tide once again drew out those same memories that he had buried by the beaches of his hometown long ago. One year, our vacation plans took us on a slight detour past some of the most breathtaking villages in our country. We could see village women in colorful headscarves, knee-deep in water, harvesting rice; fields upon fields of green tea leaves set into the sides of hills; groves and groves of lemons, limes, oranges, and *naranjes*, a tangy and sour citrus.

This was the year my father took us to Rasht, his beloved hometown. In addition to visiting his boyhood home and school, we made a stop in the town's bazaar and visited different artisan shops. While my parents looked at antiques and rugs, I drank the small glasses of tea with sugar cubes customarily offered to shoppers in stores. Years later, at my wedding in America, I was presented with the same items that I had watched them buy that afternoon from Aghay-e Yousefyeh, an artisan from that very bazaar. Their gift included a priceless collection of Russian decorative jeweled boxes and urns, which today remain my favorite sentimental treasures.

Opposite: One of my most memorable childhood experiences is peeking in the tin box called *Shahre Farang* and catching a glimpse of the outside world.

The Legacy of Chutzpah

Although I never met my paternal grandmother, I feel a certain connection to her. Indeed, when I was not yet born, she came to me in this important dream . . .

She had heard that I was ready to be conceived and had asked her entourage to seek me out and bring me to her. I was taken through a narrow, well-lit passageway that led into a grand space worthy of a queen. My grandmother's handmaid had drawn her bath, and she lay there luxuriating in the lavender-infused water, her face lit by the steady glow of the oil lamps near the bath. I was struck by the high perch of her head, how her dark hair had faded, and the way her many clusters of braids were tied with gold coins dangling at the ends.

She had a reputation for being extravagant, but I think she had a great appetite for life. Toward the end of her days she was stricken with a rare disease and could not hold down food for more than thirty minutes. But she made no fuss about it. She still woke up early in the morning to greet the nightingales outside her balcony that sang their hearts out for her. She still tended to her azaleas and yellow roses. She made no fuss.

Every morning she hummed a tune while she brewed herself her secret mix of herbal tea, made two eggs sunny-side up, and toasted fresh-baked bread—the kind that is baked in a *tanoor*. She ate each meal with delight and regurgitated everything a half hour later. She did not feel victimized by the death of her nine-year-old son, or by the death of her other son at the age of three. She did not feel victimized when her husband died and left her to take care of three kids. After the regurgitations, she would come back smiling.

"Life is too good for me not to enjoy everything, even the eating," she said.

I guess I caught a glimpse of her inner spirit when she glanced at me while bathing in the fragrant water. She did not speak at first, but motioned for me to come closer. I wasn't sure what I was doing there. I felt small and shy, like an interruption, as if I weren't supposed to be watching her. I could tell she was growing impatient with my lack of resolve.

"Come on, little girl," she snapped. "Do you think I have all of eternity to wait for you? I want to tell you something before you go off on your own." I took a few small steps toward her—four, to be exact.

"Listen, child, in my lifetime many thought that I was ripe for the asylum. But I didn't care. I loved what I did. I taught myself to be myself. Now you listen. You are the heir to many unlived lives. This is the legacy you carry in the cells of your body. Don't shrink away from life. Live generously. Have the chutzpah to give birth to your many selves. In life, don't just stick to what is purposeful and rational. I say you sometimes have to do things that you feel have no purpose at all. Then it all becomes lighter, almost a game. Then you will be the art and the artist. You understand?"

Digging my nails into the palm of my hand, I bowed my head while my eyes remained on her. Of course, I did not understand a word that she said. It all seemed like a riddle. She kept her gaze on me. "Oh, and one more thing, little girl: When you go out and about, buy yourself a magnificent aquamarine ring. Not a small one, a big one. It really is a maaaaarvelous thing to wear. Now run along."

That was it; that was all of it. She turned her head, cupped her hands in the water, closed her eyes, and poured the water in her palms over the crown of her head.

Many moons passed before I learned more about my grandmother. My mother told me stories of her grand way of living when she was young and married in Rasht. "After temple services, she rode around town in the most beautiful carriage, which they'd purchased from Russia. She wore elaborate clothes, with gold coins dangling from her henna-tinted braids. She always hosted the traditional Shabbat lunch in her courtyard. You know, she had the whole thing, with the lentil soup, tea-stained eggs, fried zucchini and eggplants. She was quite the cook. And, would you believe, she used to cover the entire length of her courtyard with fine silk rugs for her guests."

My sister did not know our grandma's glamorous side. To Lida she seemed more like an eccentric. "In the afternoons," Lida said, "Grandma dressed in Western clothes, pleated skirts,

Preceding: The Persian paradise garden, a representation of the afterlife, was a place for sacred contemplation and spiritual nourishment. *Opposite*: My paternal grandmother, Khanom Jaan, whose feisty attitude and zest for life is reflected in her pose.

hats, and all, which was not the usual fashion choice of a widow. People on the streets actually pointed at her because she dressed so oddly. She used to catch a bus and ride around town for hours, as if she were touring the city. She loved to watch people."

Although I had heard that my grandma had quite a temper, my father talked only about his mother's spirit of adventure: "Her dream was to move to Israel. It took me weeks to take her from Iran to Israel. First we went to Turkey, then to Germany and France, and then back to Turkey. We drove across the continent. She managed to live in Israel for years without learning the language or knowing anyone. She came back to live out the last years of her life with us."

She certainly had chutzpah. But what was Grandma trying to tell me?

I asked my mother if she remembered an aquamarine ring on my grandma's hands. "No," she said, "she had a Persian turquoise ring with diamonds around it, not an aquamarine. But do you know that aquamarine is your birthstone? It's said to bring clarity."

Years later, as a young woman, I went on a blue-sky holiday to Venice, Italy, during Carnival time. The Tuesday before Ash Wednesday was the final night of Carnival, and it was marked by true extravagance. Food and wine flowed in abundance; private masked parties were held in palazzi and hotels. Thousands gathered in the Piazza San Marco, the main square in Venice, to enjoy a night of music and dance, and to watch others who had come from near and far all dressed in the finest of costumes. Hundreds waited in line to take part in the spectacular procession and show off the intricacy of their ensembles. You could tell that some had spent months on the details. Their mannerisms, the tilts of their heads, and the movements of their arms mirrored the selves they wanted to express:

The King and the Queen, with their regal demeanor, rulers of their desires; the Jester, who danced about in a frenzy; the Warrior in full armor, carrying a sword with unparalleled courage and focus; the refined and sophisticated Geisha; the Wise Old Man, with an owl, the gift of second sight, at his side; the Magician, ushering in the mystery; the Bride, with her yearning for union; the Seductress, with her lust for life; Spring, adorned with the promise of bloom and all beginnings; Death, the daughter of Night and the sister of Sleep; and the Tree of Life, the embodiment of all there is.

While I was standing in the square, watching the procession, I heard the jingling of gold coins. I was struck by the feeling that I finally understood what my grandmother meant. I want to live out all my lives in this one. I have faith that the aquamarine ring will present itself in due time.

Opposite, from top: Costumes at Carnival; the labyrinth of Venetian canals.

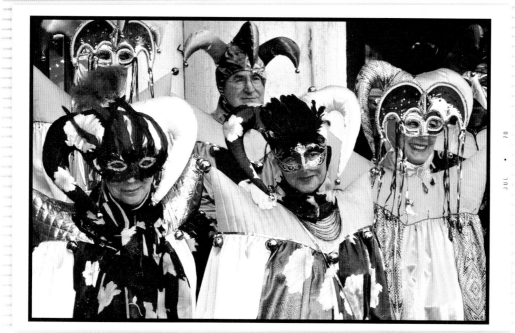

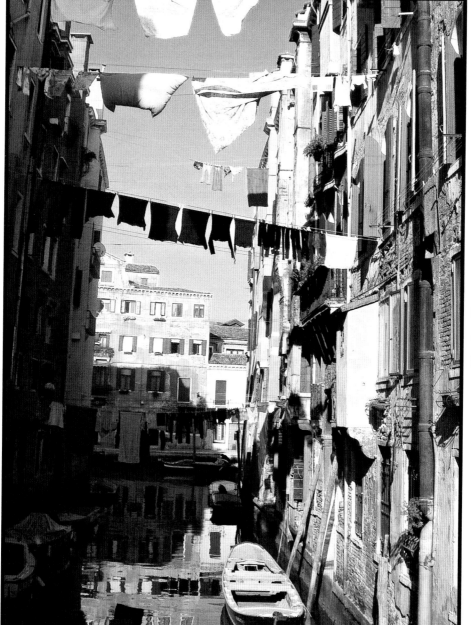

Trouble on the School Bus

During the school year, my days had a predictability and a routine all their own: Studies, and occasional weekend outings to the movies. It was fashionable for most upwardly mobile families in Iran to send their children abroad to study, especially the boys. Indeed, it was the crowning symbol of a progressive family that wanted to provide the best opportunities for the children. If the kids were not sent away, then they studied at one of the many private bilingual schools that had sprung up in the city. I attended one that taught English and was a convenient fifteen-minute walk from home.

Every morning, from the time I was five until I reached the fourth grade, my mom used to take my hand into hers and walk me to school. She walked briskly and with determination. I was usually three steps behind, always trying to keep up. She seemed to spend her days in a constant rush, busy with errands and household chores. Although many families we knew had a driver and lots of help in the house, my mother, who stayed true to our family's stay-busy, work-hard ethos, refused to have anyone except an occasional housekeeper.

As we walked together to school, I was filled with pride that the woman holding my hand was so beautiful: alabaster skin; fine, light brown hair; and soft features. These were the standards of beauty that the Anglophile culture of Iran valued most. Many people complimented my mom on her European looks and my father's light skin and blue eyes. None of their children inherited the much-coveted blue eyes—and I was born with olive skin that kept getting darker because of the summers spent by the pool.

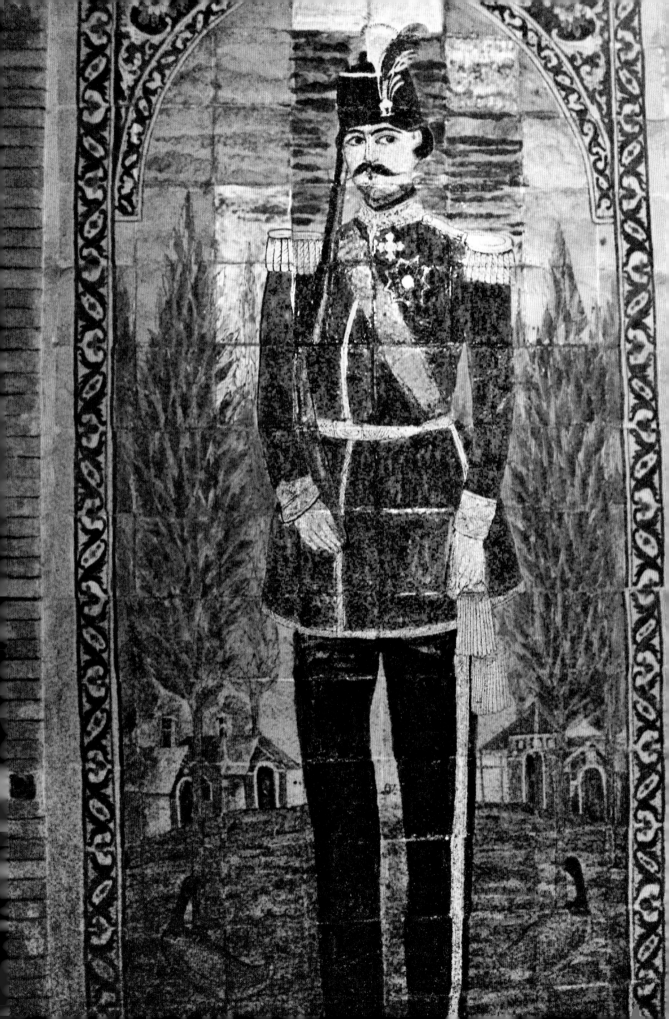

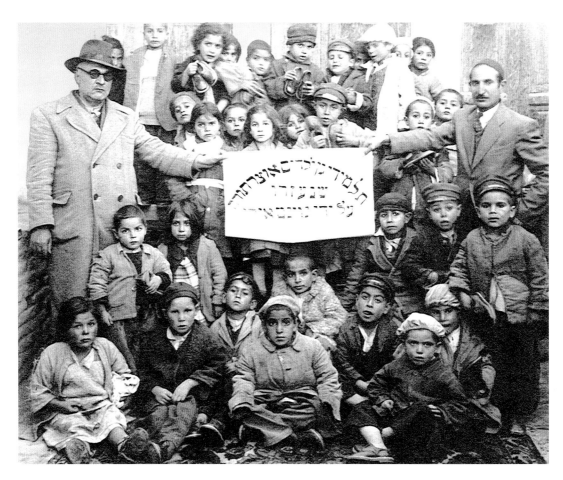

Although I wanted to look like my mother, I still thought my complexion was not as ethnic as that of my close friends in school. Panthea and Azita, my best friends since kindergarten, had walnut-brown eyes and coal-black hair and complexions as dark as the brown bark of Iran's willow trees. They were Zoroastrian, and they often told me their family roots in Iran ran as deep as two thousand years. I was not surprised. Zoroastrianism was one of Iran's original and most ancient religions, dating back before Islam. I knew our family had come from the southern parts of Spain during the Spanish Inquisition. This was relatively recent in the context of Panthea and Azita's lineage. Both Zoroastrianism and Judaism were minority religions in Iran, and out of deference to our religious backgrounds, we three girls were allowed to leave class during Islamic studies on Thursday afternoons. This sign of respect for our religions no doubt still set us apart in the minds of our classmates.

My experience as a Jew growing up in a predominantly Islamic country was markedly different from my father's. He told stories of having been beaten and chastised on his way

Preceding: Tiled wall from Tabriz, Iran. *Above*: a Jewish school run by the French nonprofit Alliance Israélite Universelle in Isfahan at the turn of the twentieth century. Education was an important means of advancement for Iran's minority Jewish population.

to school. Traditionally, the treatment of religious minorities varied in accordance with the policies of the government. The Jewish population was but "a glass of water in the sea," as we referred to it, with only 80,000 throughout the country. Over the years, Jews in Iran had suffered intermittent oppression and persecution, and sometimes whole communities were forced to convert. During my father's childhood, Jews had secondary status and were targets of discriminatory practices and attitudes. My father used to recall how people referred to Jews as *najes*, or "polluted." It was only when Reza Shah came to power in 1925 that Jews were able to come out of their ghettos and integrate with the larger society. During the shah's reign, Iran's Jews moved fully into the economic mainstream and benefited from all the opportunities of the economic boom. The shah also made the bold move of officially recognizing the State of Israel. Nevertheless, Jews retained a distinct identity, even during these prosperous times. They may have conducted business with everyone, but most still socialized among themselves. While growing up, I did not experience any religious animosity, just a sense that I practiced a different religion than most kids in my school. Little did I know what was soon to come.

The first ten years of my life blended seamlessly. Any day could have been any other day. I was enveloped in my cocoon, the ever-present comfort of routine, especially during the week. On weekends Kourosh and I ventured outside to our cul-de-sac street and played with the neighborhood kids.

But once I turned ten, all that changed. The bigger world seeped into mine. I was in the fifth grade and would read my father's newspaper out loud in the evenings. I was a bit of a show-off, but I was pleased to let him know how well I could read. The Farsi alphabet is challenging; many of the vowel sounds are not built into the written word to help with pronunciation. So reading aloud was a way to get my father's attention and impress him at the same time.

One evening I read about a fire in a movie theater that had claimed three hundred lives in one of Iran's outlying villages. The fire had been set intentionally, and the exit doors were locked so that no one could escape. My stomach churned as I looked at the photos in the magazines. Hundreds of charred and trampled bodies lay near the doorway. The article spoke of civil unrest and impending rebellion. I looked at my dad, trying to make sense of what had happened. I was stunned to see that his blue eyes showed nothing. He simply got up from his chair and said in a casual tone, "I don't think you should be going to the movies for a while, at least not for now."

The last time I had been to the movies, I had waited for hours in a line that wrapped around a city block to see *Star Wars*. Many of the neighborhood kids, including Dariush's friends, were at the theater that day. The teenagers clapped and rooted for Luke Skywalker in

every scene as if they were at a live performance. What would have happened if someone had decided to set fire to that theater? Would we all have been trampled while scenes of cosmic battles flickered on the screen?

If Jamshid were still at home, I would have gone to talk to him. But it had been three years since he had left for the States. If Kourosh were still at home, I would have sneaked over to his room to talk to him about that article. But months before, he had left Iran to continue high school in California, and was now living under Jamshid's supervision in Los Angeles. I went into my room, alone, changed into my pajamas, and sat on my bed.

I missed Jamshid. Inevitably, scenes from the night before he left came to my mind. That evening, I had run into my room, hidden underneath the bed, and cried when I saw my mom approach with his bon voyage cake. But Jamshid had come to find me. He crawled underneath my bed, squeezed my hand, and promised to write me soon. A month later I received the first letter anyone had specifically addressed to me. He talked about Southern California's great weather and the many parks that were in the neighborhood. He was impressed by the warmth and friendliness of his American colleagues and had already been invited to dinner at their houses a few times. I saved his letter in a special shoebox I hid in my closet.

I got off my bed and went to the closet to get Jamshid's letter. It was now tearing at the folds from my rereading it so frequently. While I was holding the letter in my hands, I wished I were with my brothers in California. Lonely and confused, I went by Dariush's room to see if I could talk to him about the fires in the theater. He was not home.

I thought about calling Lida, who had moved back to Iran with her husband and four-year-old daughter. The year before, she also had wanted to leave Iran to settle in the States with her family. My father had been shocked. "What's wrong with young people these days?" he demanded. "It's one thing to study abroad, but why not live here? There are plenty of opportunities in Iran. Look at the Jewish community here, everyone has done so well." My father was right. Many Jewish families were thriving, having moved out of their insular ghettos into posh neighborhoods, driving expensive cars, and vacationing in Europe and the States. My uncle even had a high-ranking post in the shah's government. Lida and her husband finally decided to stay. They rented an apartment nearby and enrolled their daughter, Natasha, in an international nursery school, and my brother-in-law set up his medical practice.

I made my way toward the phone to call Lida. I turned my watch to catch the light that was shining in from the streetlamp outside and was disappointed to see that it was 9:30—too

Opposite: A crowd of demonstrators chanting anti-shah slogans making their way through Tehran towards Esfand Square (now Revolution Square) in December 1978. At the height of the revolution, demonstrations demanding the shah's removal were held almost daily in Tehran, practically paralyzing the monarch's regime.

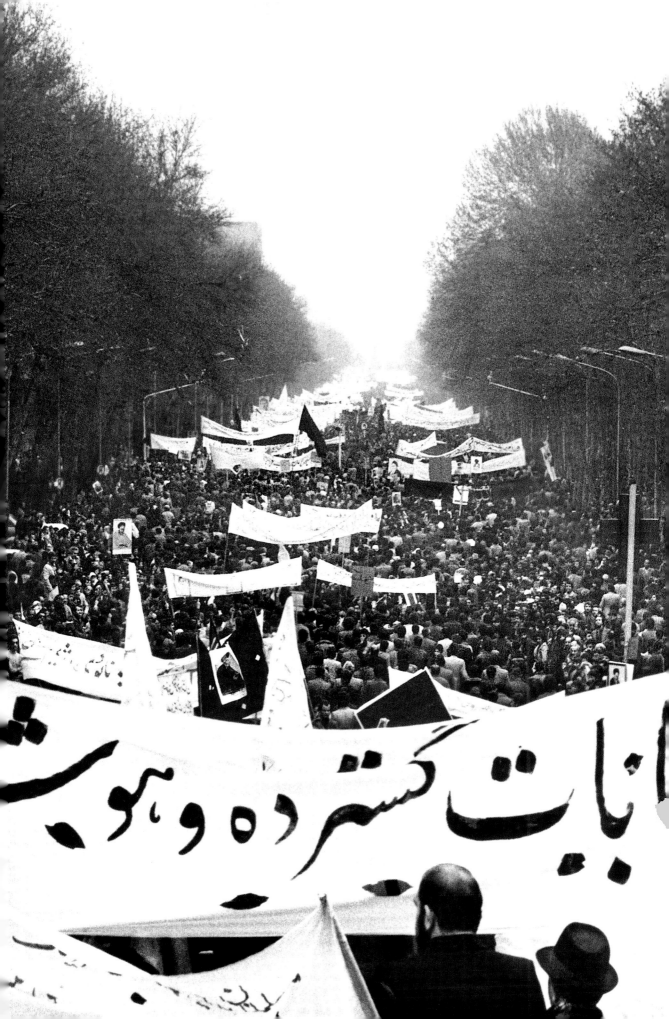

late to call Lida and disturb her family. So I turned and went back to bed, confused and scared. Everything was in flux; our household was a whirlwind of siblings leaving and coming. Every year my parents would go for long visits to Europe and America to see my older siblings, while I stayed home with my grandma and, until recently, my two older brothers. Now it felt as if home, as I knew it, was shifting under my feet. Our country was in the midst of sporadic uprisings. The words in the newspaper rang in my ear: "demonstrations in the villages nearby," "signs of civil unrest in the country." That night I could not sleep. Images of people burning to death seared my mind. It was the first sign that my safe little environment was coming undone.

> 66 *It felt as if home, as I knew it, was shifting under my feet.*
> *The words in the newspaper rang in my ear: demonstrations in the villages nearby,*
> *signs of civil unrest in the country.* 99

As the year wore on, the faraway demonstrations I had read about spread to Tehran, involving thousands of people. Periodically I heard angry mobs protesting in the streets by my school and outside my house, chanting anti-shah slogans. I had started sixth grade in a new school—a Jewish day school named Etefag—across the way from Tehran University, which was the hub for student demonstrations. One afternoon, as we got on our school buses to go home, a deep male voice came through the loudspeakers of the school. "School buses are not allowed to leave the school grounds. Students, please remain seated until further notice."

At first we didn't know what to think. Distant chants could be heard from outside the schoolyard walls. We assumed the nearby streets were jammed with demonstrating students. We stayed in the bus for half an hour, but even that half hour dragged on eternally to us kids on the bus. Most chatted nervously with each other while some of the boys threw spitballs at the girls in the back. Our driver, exasperated from all the commotion, shouted with his booming voice, "If you don't sit down, I'll give your names to the principal!" No one paid attention to his empty threats.

Minutes later, we heard what we thought was gunfire, followed by the sound of police sirens. There was silence on the bus. This was almost too much for a ten-year-old. From the back seat, I could see some kids had buried their heads behind the seats' high headrests, some were searching to see where the sound had come from, and some had grabbed onto their friends. I grabbed the backpack on my lap. We were only four weeks into the school year, and I was still the new girl. My best friends, Panthea and Azita, had moved on to another, secular school. I missed them a lot. If they had been on the bus, I would have had someone's hand to hold . . . someone to talk to. Instead, I squeezed my eyes shut and ran my fingers over the stitching of my bag, wishing I could be in California with my brothers. But that was

a dream. My parents often reminded me that studying abroad at such a young age was not appropriate for the girls in the family. After a couple of minutes, the kids on the bus started whispering, asking where the sound had come from. A girl seated up front started crying. Soon our science teacher, Mr. Tabrizi, jumped on the bus, dripping with sweat, to reassure us. "Don't worry. You are safe," he said. "The sound you heard was not a gunshot. You are safe. Just stay put and we will leave soon."

We didn't know if we should believe him. "They could've shot rubber bullets, you know," said a boy seated up front.

"Maybe they were real bullets, or tear gas," another boy yelled out. That sent the rest of the bus into a frenzy.

"I don't want to be on this bus anymore . . . I want to go home!" the girl next to me cried.

The frustrated bus driver tried to quiet us down. After fifteen minutes, the buses were allowed to pull away and leave. All the streets by the school were barricaded by police. The vendors outside selling snacks were nowhere to be found. Crowds had gathered. I knew that something really awful had taken place outside the school walls.

That afternoon it took an extra hour to get back home. After that incident, our school shut down for two weeks. Soon the oil workers went on strike, which brought the country to a standstill. Gasoline was rationed and cars lined up at service stations. Some days, when school was in session, I would wait outside our house for close to half an hour, only to discover that the bus would not pick me up that day. Roadblocks sprang up all over the city, creating a maze of confusion. These barricades forced the bus to skip over entire neighborhoods.

Though these were my first real experiences with the political upheaval of the day, I soon learned they were not to be isolated incidents. Anti-shah protests grew from weekly to daily events. SAVAK, the shah's infamous secret agency that had surveillance throughout the universities and governmental infrastructure, responded with more force. Agents arrested, detained, interrogated, and tortured the opposition in their own prisons. Riot gear, gas masks, and submachine guns became the norm for police. In the past, the regime's intimidating grip on demonstrators and the dissidents' horrifying accounts of torture and killings had suppressed the opposition. But now, students and the working class of Iran had sensed weakness in the government. Sheer force and intimidation no longer brought blind obedience. Opposition to the shah deepened, violence escalated. I never gave myself the permission to ask my father what would become of us if the government were overthrown. But I could sense the tension in the house, and the air in the streets pulsed with energy and hostility. Everyone was on edge. I could sense that things were taking a turn for the worse.

Worlds Apart

*"**Get out of here.***
Go back to your homes.
This is not a safe place to be.
The government, the president,
is overthrown!"
That's what the old lady
screamed in the synagogue
before she shuffled out
and shut the door,
face white with terror.

My mother-in-law,
calm, collected,
withstanding a million stray thoughts,
turned to my kids with a tender smile.
"Boys, go stand by the bema for a picture,"
she said, disposable camera in hand.
The kids out of earshot,
she whispered,
"For God's sake,
we came to see Argentina,
now we're in the midst of a rebellion."
On our way
to the synagogue,
*our driver had made a **wrong turn***
and took us to a street
filled with an angry mob
hurling stones,
beating each other with sticks,
chanting and screaming.

We left the synagogue after
that picture,
and stayed the rest of the day
in our hotel.
We played cards with the boys
and ordered room service.
penne all'arrabiata set our mouths aflame
as we drowned out the jeers
of the raging mob outside
with Chilean wine.

1995 must have been a good year.
On TV, a serious man,
hair gelled to the side,
reported three people bludgeoned to death
in the demonstrations.
It's eerie how experiences
worlds apart
plant themselves
in the same space of time.
Did the three scream
as we drove by,
or was it while we
were drinking café con leche
in the ritzy Alvear Hotel,
complaining our coffee wasn't hot?

It grew dark
at last,
even silent.
I leaned out the window.
The streets were empty.
Three nights without the moon.
And here I stand
looking at the night sky.
Trees rustled in the wind,
a warning of the coming storm.

That night,
as I leaned out the window,
listening to the rustling of the wind,

a moment experienced worlds apart
resurfaced in the same space of time.
That night,
as I listened to the rustling of the winds
and watched the milky smear
in the moonless sky,
I wondered if these were the stars
that hovered over me
in Iran when I was eleven.
A young girl,
head upturned,
brimming with dreams of faraway lands
with turmoil and rebellion pulsing in the air.
I thought I'd come **so far,**
yet we were still,
me and the stars,
and all that exists between us.

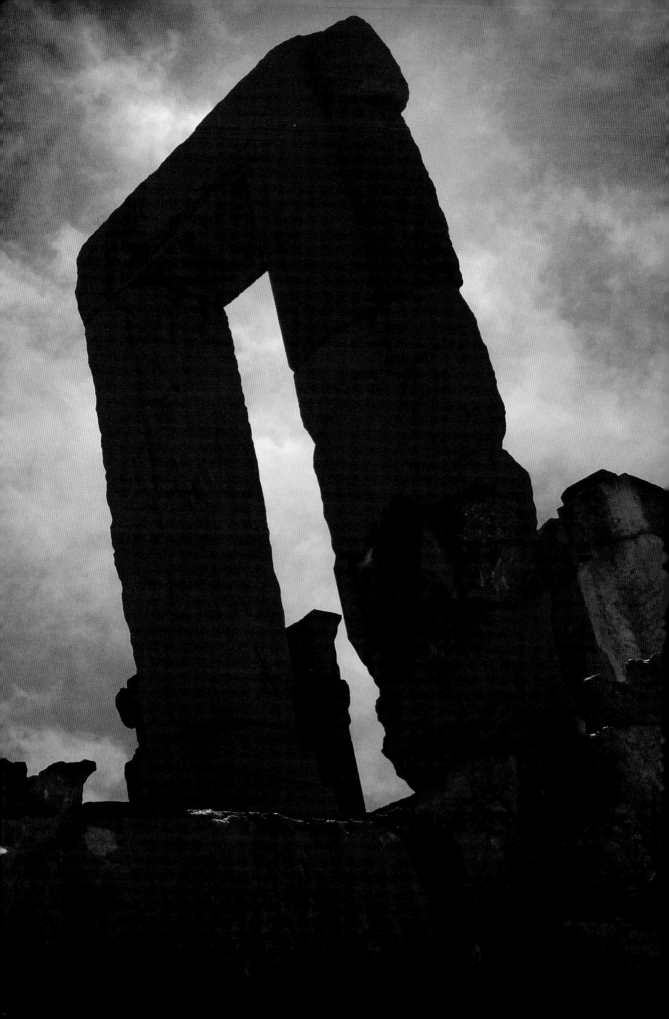

The City Aflame

One Thursday afternoon, two months shy of my eleventh birthday, I was sitting in the den reviewing my math homework when I heard explosions and gunfire. I rushed out of the room. My parents were already by the doorway. "Where did that come from? Are you okay?" I could sense the fear in my mom's voice.

I pointed to the windows in the family room and said, "Did you hear that blast? It came from out there. Do you feel it? The windows are still rattling." We looked out the window but saw only the trees in the nearby park. Politics. There was nothing to do but sit around the table in silence. I kept stealing glances at my parents' faces, trying to gauge whether I should be worried. My father's eyes looked remote; my mother's were more telling and restless.

My mother got up, then abruptly sat back down. "Lida. I need to see if Lida is okay." She dialed my sister's number and waited on the line, holding the receiver with both hands. "Did you hear the blast? Are you all okay? How is Natasha?"

My mother's face relaxed and I could tell that things were fine on the other end. "Be careful. Don't go out, okay?" she told Lida.

Just as she hung up the phone, my mom turned to my father and said, "I'm telling you, this is getting serious."

"Calm down. Do you know how many times Iran has been on the brink of revolution? I've been through this before. Just . . . "

My father's words of reassurance were interrupted by the sound of sirens in the distance. He got up. "I'm going to the roof to see what's happening."

We followed him up two floors, my father taking two steps at a time, the keys in his pocket jingling with each step. Once he got to the top of the stairs, he discovered the door was jammed and had to slam his shoulder against it to force it open. He walked to the edge of the roof, his hands in his pockets. Standing there, he looked out and shook his head.

I wanted to go stand next to him, but I was afraid of heights. I stayed close by the doorway. But a sense of both curiosity and courage boiled up, and I found myself inching my way toward my father. I stood three feet behind him, arms wrapped around myself, and looked out. Instead of being overwhelmed by fear, I felt an odd sense of calm. It felt as if I were watching a bizarre scene happening to others but not to me. I just couldn't believe it. Buildings across the city were on fire, smoke billowed across the horizon, and the setting sun glowed ruby red.

My dad once told me of the time when he, at the age of four, sat inside a boat with his father, off in the Caspian Sea, watching the Bolshevik invasion from afar. It was night and the first chill of winter had set in. He and his father huddled together in that inky darkness, completely still—listening to the rhythmic sound of the waves slapping their boat, watching their home-town burn from a distance. Now, a generation later, I was with him, and our eyes glazed over as we watched Tehran in flames.

"It's nothing," he said. "It's nothing. Everything will be fine." It seemed to me that my father had fixed his gaze upon some scenery so remote and mysterious that only he knew of its existence.

We went downstairs and huddled together in the family room. My mother was lost in her own thoughts. Dad sighed and flipped on the television. In those days, there were only three channels on Iranian TV—all state-owned—and only two broadcasts in the afternoons. Footage on Channel 2 showed police randomly grabbing people, beating them with batons, and tossing canisters of tear gas into the crowds. People were scrambling, blood on their faces.

If I had any doubts before, I knew my father was wrong once I saw the club-wielding cops on TV.

Something terrible was happening in our country. From that day, the city was under martial law. When I went to bed, I heard the roar of tanks and cars, along with spitting gunfire through-out the night. I wanted to return to my childhood cocoon. All I wanted to worry about was getting an A in math or mastering my science homework. I pulled the blanket over my head and huddled in the womblike darkness.

That evening, while I was listening to my breath under the blankets, hands wrapped around my knees drawn to my chest, I made my first grown-up decision: I pledged not to make things

worse for my parents. They had so much to deal with. In addition to his own children, my father had the responsibility of his widowed sister and her kids. My mom, the oldest child and only daughter in her family, had the added pressure of worrying about her aging parents. No matter how afraid I got, the last thing I wanted to do was bombard them with my questions and demands.

We all know kids are often more savvy than their parents think. Mine thought I didn't notice, but each time I walked in on them, they quickly stopped talking or changed the topic. I put together a lot of things from the bits and pieces of their conversations. I found out that the demonstration we had witnessed from our rooftop had been the biggest ever, involving some two million people. I heard them as they talked about the word on the street—how troops had injured and massacred more than two thousand demonstrators that day. In the weeks that followed, while school was out, I escaped the violence swirling around us by mindlessly watching TV and reading a book about a pony named Corey.

In mid-November, two weeks after my birthday, I heard my parents' hushed voices in the living room. I was watching *I Love Lucy* in the den but heard fragments of words—something about missing school, safety, and visas. I tried to pay attention to the show, but I was much too interested in what was happening. So I tiptoed out and stood near the wall where I could hear.

"You need to see if we can get a travel visa for Angella," my father said. "Let's also see if Lida and Natasha want to go along. I'm sure everything will be back to normal in a couple of months."

"I don't know," my mom replied. "Things look so bad. Are you going to be okay staying here? What if Angella misses a lot of school?"

"I am perfectly fine. Things will blow over in a couple of months . . . nothing to worry about. And what's the point of you and Angella staying here? She hasn't had school for the past fifteen days. Let's just see if we can get the visas first."

I sneaked back to my chair. A few minutes later, I heard my father approach and sensed him looking at me. I pretended to be absorbed by the show. Lucy and Ethel were sitting on Lucy's couch, plotting to dress up and crash Ricky's nightclub.

Lucy, along with other American shows such as *Charlie's Angels*, *The Six Million Dollar Man*, and *The Donny and Marie Show* were the most popular programs in Iran. They were all dubbed in Farsi. Posters of Farrah Fawcett, with her toothy smile and feathered blond hair, were everywhere. Photos of the dashing Lee Majors were sold at newsstands across the city. Lots of girls in my class had puppy-love crushes on Donny Osmond, and I thought the brother-sister pair, and their singing siblings, were the perfect vision of a close-knit, happy American family. All the characters on these sitcoms were perfect and happy, courageous, and charming. In my eleven-year-old mind, I concluded that all people who spoke English lived in bliss.

My father had been standing before me for some time. He craned his neck over my

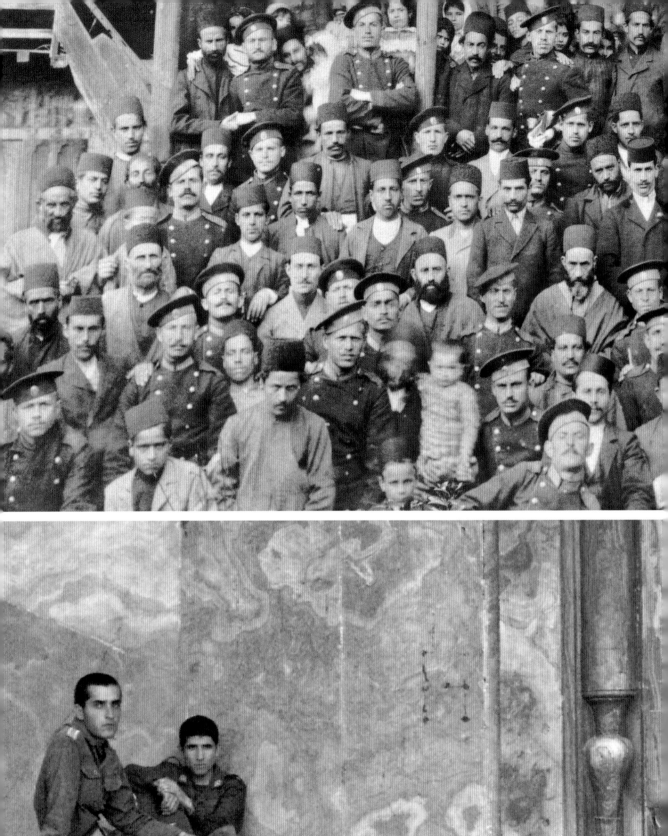

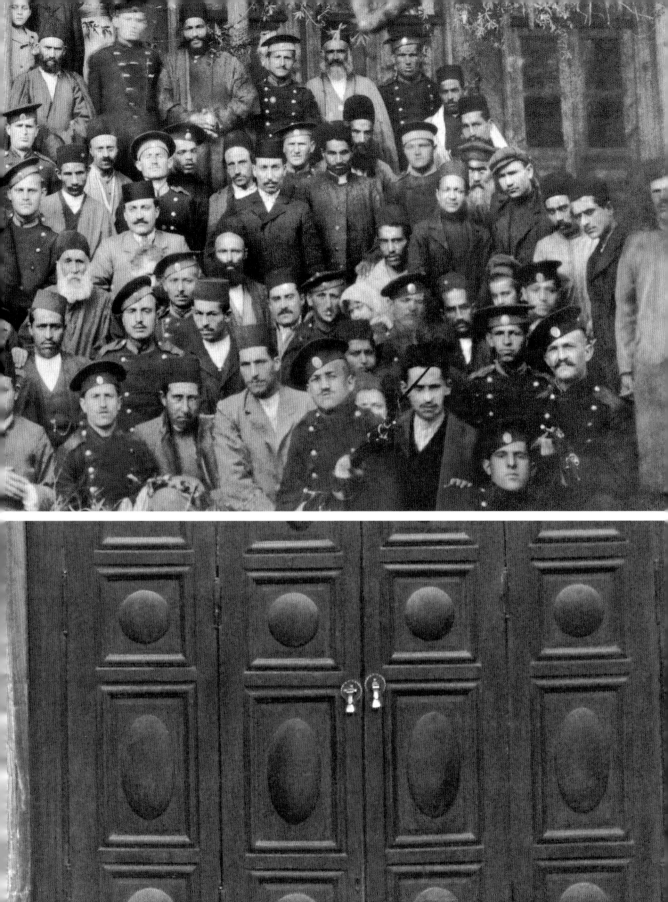

shoulder. I did not budge. I thought he had discovered my eavesdropping, and I dreaded his anger. He walked across the room and turned off the TV. He was frowning, his mouth tight, his hands folded in front of his chest. I started playing with the edge of the white lace tablecloth.

"Listen. Your mother and I have decided that you will be going to America to visit your older brothers. You will go with Mom, Lida, and Natasha."

"I'm going to America? When will that be?" I asked, pretending to be surprised.

"We don't know when you will be going, but we'll find out soon."

"How long will I be there?"

"You are asking so many questions. I don't know yet, maybe two or three weeks, depending on when you leave. In December would be a good time." He let out a long sigh and looked out the window. It was already dark. He turned back and looked at the shelf behind me, avoiding my face. "Yes. We'll see what happens." He put his hands in his pockets and walked out of the room before I could ask any more questions. I knew my father was agitated, worried even. But for the time being I wanted to savor the elation that flooded through me as I thought about making my first trip to the States and visiting my beloved brothers.

By the end of November my school was shut down again because of student demonstrations. I spent my days packing and unpacking for my trip. I organized my birthday gifts in my closet, underneath my party dresses, next to the shoebox that I had filled with letters and special notes. I had received a heart-shaped charm for my necklace, a pink sweater, and a photo album with yellow daisies on the cover. The charm was still in its box. "I'm going to leave them there until I get back," I thought. "I'll put my travel photos in the album and show off my new charm to all my friends at school when I get back."

My mother spent these days waiting in line at the embassy. We couldn't leave without a visa, so every afternoon, as she came home, I greeted her by asking, "So, did we get the visa today?"

"It still wasn't my turn yet. Maybe tomorrow," she would say with an impish grin. Those days dragged on forever for me. I wondered if the embassy would in the end grant us visas. Thankfully, after a week, my mom came home with an announcement.

"We have everything. We're leaving next Wednesday, early in the morning." I jumped around the living room and ran to call Lida with the good news. Lida, who was now four months pregnant with her second child, did not sound as excited over the phone. I could tell from her many discussions with my dad that she was less optimistic about the situation in Iran. Perhaps she knew this was not going to be just another trip.

Preceding: Civilians with Bolshevik soldiers who defected to Rasht in 1920 *(top)*; Iranian soldiers *(bottom)*.
Opposite: Excerpt from the poem "Call of Commencement," by Sohrab Sepehri: I must go tonight. /
I should take with me the suitcase / That holds as much room as the robe of my solitude / And set off…

The Blood of Our Fathers

It was the metallic, salty
smell of blood,
fear's sweat
and the staleness of hunger
that lingered in the air
the summer of my tenth birthday.

It was their feeble attempts—
reining in the frightened lamb,
its sharp thin cries,
the struggle
to tear it from life's grip,

the splattering of the **blood**

on courtyard walls,

the stories I'd heard,
of the binding of Isaac
the blood sacrifice
and the irony of the blaring truth
that there is **no mercy** in mercy killing—
even with a swift cut of the jugular—
that made me feel oceans away
from my father's life.

There wasn't a single landmark
by which I could recognize
his childhood world—
a maze of rutted alleyways,
the cool shade of willow trees
and the **imprint** of carriage tracks
on mud and stench.

I had never seen
those mosaic fountains in courtyards,
where generations sat on fine silk rugs,
listening to the **hiss of the samovar**
and playing with worry beads,
sipping steaming cardamom-jasmine tea.
How could I recognize
the clamoring of Bolshevik boots,
the thousand people laid to waste
in the streets where my father walked?
It began that summer—

the roar of tanks,
sparks of fire in the streets,
petrified voices, thin as thread,
the thud of batons hitting flesh.

It began that summer—
the look of murder on faces,
the blood flowing in the streets,
life, **real life**,
not the storied tales passed down
from generations back,
the blowing of the ram's horn,
the dry bones of the sacrificial lamb
buried somewhere
in the cold, hard earth.
There is a loss
in knowing that my children, too,
will never recognize
the shapes of the world
I left behind:
the street peddlers

hawking trinkets on carts,
the taste of water-soaked walnuts,
those bending birch trees lining my home,
the goldfish swimming in shallow pools on New Year's Day,
and the dark **crimson glow**
of the setting Caspian sun.

The Crossing

It was still dark when my mother woke me up to get ready for the airport. I didn't know it then, but this was to be the last day I would spend in my native Iran. It was just a month after my eleventh birthday.

After a simple breakfast of feta cheese, bread, and tea, I went to my room to put on one of my favorite dresses, which I had put aside for the big day. It was a beige knit dress that my mother had bought for me while she was in the States visiting my brothers the year before. For a cold December day, it was just perfect—long sleeves and a warm collar that turned up, almost like a turtleneck.

As I slipped it on, my mom walked in the room with an ordinary cardboard box. Inside the box was an array of jewelry—rings, bracelets, and necklaces that she had been collecting over the years. Some were family heirlooms; others were items she had bought on her travels abroad. At the time it wasn't apparent to me, but my mom was worried about our future. These gems were, in their own little way, our security.

When I look back now, I see that these items are really the only tangible things that link me to my native land. We didn't bring furniture. Not many clothes. No art. If you've never had to leave your homeland forever, the importance of these "things" might be harder to understand. Most people have family treasures collected over a lifetime of patterned tranquility spent in the same town or the same neighborhood. These are items that offer validation of what their keepers have experienced, cared to remember, or loved in the world. They offer their keepers a sense

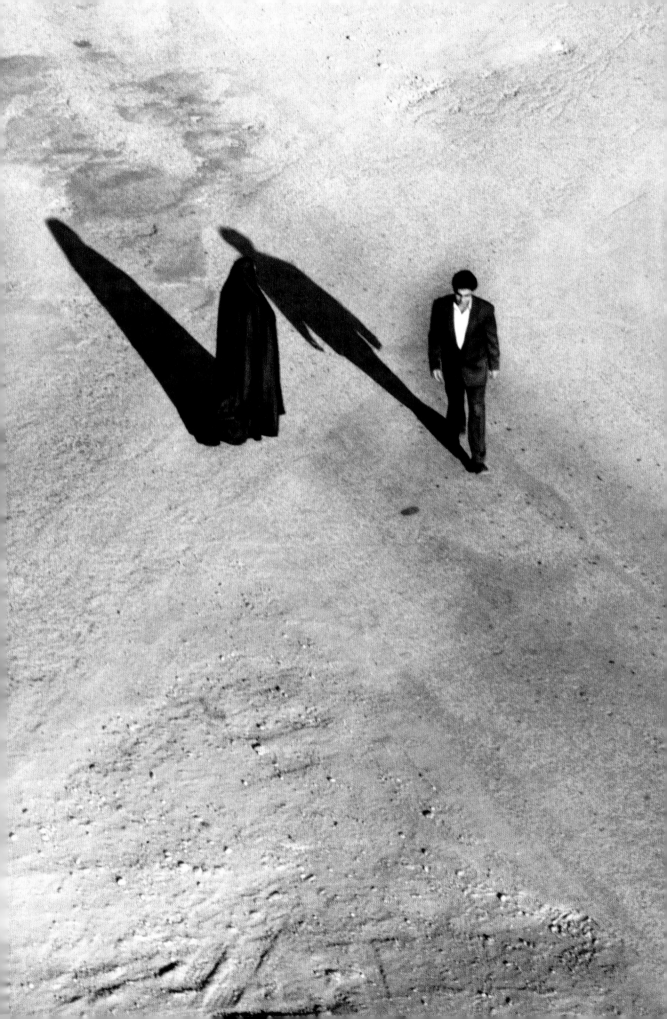

of identity and continuity. Perhaps they are small things like childhood books and clothes, birthday cards, and little mementos. For us it was what we brought with us in haste, almost as an afterthought, that December day. For us, it was the necklaces.

"Here, wear a few of these under your dress," she said. "Don't wear them over your dress, okay?"

I looked at the three gold chains that she had set aside for me. "Why should I wear them under my dress, Mom?" I asked.

"I'm doing the same," she replied. "I just want to take a few of our valuables with us on the trip and I don't want to leave them in the luggage. Besides, I'm not sure if the security in the airport would like to see all this hanging around our necks." Nervous and excited at the same time, I took the necklaces from her and clasped them one by one around my neck and under my dress. For a change, I was let in on the grown-ups' secrets, and I wanted to prove that I could pull my own weight.

It was 5:30 in the morning, at the first light of dawn, when we left home for the forty-minute drive to the airport. As I sat in the backseat of my father's car, I watched the shifting colors that played in the sky before the rising of the sun. By six, the sun's rays peered from behind the rim of the Alborz Mountains and glimmered through the mist ahead. As we passed through the fog, I felt myself moving through a luminous halo. A good omen, I thought. I rubbed the charm bracelet I was wearing and prayed that our two-week vacation would somehow be extended. I felt guilty about my secret wish, but that was what I wanted.

Though the ride to the Tehran airport was calm, the terminal itself was a madhouse. As my father pulled up to the curb, the sidewalk was overflowing with luggage. People were scrambling. Faces were tense. It was nothing less than a mass exodus.

> 66 *Though the ride to the Tehran airport was calm, the terminal itself was a madhouse. . . . It was nothing less than a mass exodus.* 99

These people were not leaving on a vacation. No, thousands of them were squeezing past one another, their eyes wide with fear. For a few seconds I thought a fire must have broken out in the terminal and the crowds were in a wild rush to save their lives. But logically I knew if that were the case, people would have been leaving the terminal, not fighting to get through.

Squabbles erupted and I heard the shrill sound of people's rising voices. Some were cutting in line. Old men were complaining. One woman who was standing next to me raised her handbag in a menacing gesture. "Make way. I can't stand up. Let me go through."

I pressed my fingers into my mother's palm, trying to suppress my panic. If I had let go, I might have lost her in the mob. I felt hot and weighed down by the dress and the necklaces. My father was trying to make sure no one was bumping into pregnant Lida and Natasha, who was now five.

Our British Airways flight was due to depart in two hours, and we weren't sure if we could make it because the lines were so long. After an hour and a half of waiting, we were able to check our luggage and get our boarding passes. There was no time for lengthy goodbyes. My father hugged us all and shooed us away toward the security guards.

As we approached them, I noticed that the guards waiting at each checkpoint were armed. A short, stocky man with black stubble on his face was staring down the passenger in front of us—a heavyset woman with a big overcoat. "I'm not hiding anything," she pleaded. "I'm going to miss my flight. Please let me go." That was all she had to say. The guard turned to his assistant, a young woman in her twenties, and had the passenger escorted to the curtain partitions for a search.

I should have been frightened, knowing that we could get searched, too. My necklaces would be a giveaway and Mom was hiding even more. But looking back, I remember I was not afraid. Indeed, I didn't feel a thing. I had a strange sensation that I was planted in the middle of a moving scene, and only a portion of me was mechanically going through the motions. When our turn came, I looked straight into the guard's eyes. They were hooded with exhaustion. It was still early in the morning, but he looked like he had been up all night. He studied me and I stared back at him. He shifted his glance over to my mom, whose fingers were digging into my shoulder. Behind us, passengers continued to push and complain. "We are going to miss our flights. We've been standing in line all day."

The man lifted his head to check out the commotion in the back of the line and then looked back at us.

"How old are you?" he asked me, his eyes narrowing with keen interest.

"I just turned eleven last month."

"Where are you going?"

My mom moved to answer, but he held out a finger as if to silence her and waited for my response. I could feel my lungs constricting, the air rushing out of me. The sea of voices, coming from behind, swept over me in great waves. I felt as if I were drowning. The people behind us were getting even more restless.

"Please, sir, we will miss our flight."

I tilted my head, smiled at the guard, and said, "Oh, we are just going for a two-week vacation to America to visit my brothers who study there."

The security man looked at the crowd behind us, sighed, and motioned us to move ahead. Another two guards stood at the other side of the checkpoint. They asked everyone to open up their handbags and carry-ons for a quick check. One looked through our little bag. A coloring book and pencils, a small plastic container of pistachios, and a bottle of Bayer aspirin were tucked away under my mom's jacket in the carry-on. The guard popped open the bottle of Bayer to check its contents. I wondered if my mom had hidden anything—maybe a ring—in the bottle. I looked at my mom's face, but she was looking down. I looked back at the guard. He was still sifting through the bottle. He looked up and kept his gaze on my mom. My mom stared back with a blank expression.

Finally, relief. "You're fine. Go ahead and zip up the carry-on."

These images would remain in my mind for years. I was only a little girl, but I knew at some level that something was going on. Little girls know these things. Even now, whenever I see scenes in the movies of immigrants being pushed around like cargo, it brings me back. Whenever I see people crammed into small spaces, whenever I see panic at border check-points, a feeling of urgency and dread washes over me, and I travel a thousand miles deep into myself, into a slice of my own experience.

My mom, Lida, Natasha, and I made it past the guards, of course. We were lucky. Others didn't fare so well. My mom knew more than I did and her relief was more visible. She mumbled a common Persian saying under her breath as we gave our boarding passes to the attendant at the gates: "*Az haft khane Rostam rad shodim*" (We made it through the seven labors of Rostam). Rostam is the central character of Iran and a mythical hero who goes through seven different trials as he crosses the desert, slaying dragons and fighting demons to save his sovereign. My mother was right—those few hours spent at the Tehran airport were nothing short of *haft khane Rostam*.

Once we were on the plane, we sat in our seats with our belts buckled for an hour, worrying. We knew that we had probably missed our connecting flight in London. Maybe they wouldn't let us take off after all. When we did taxi down the runway and the wheels finally went up, I was able to sit back and relax. It has always been in the safety of my aloneness that I allow myself to feel and reflect on stressful events. Scenes from the morning in the airport clawed their way back to me. I felt a tightening around my chest. What would have happened if they had searched us? Would we have gotten arrested? I could hear moans and muffled crying from all directions in the plane. Were we going to be sent back? The plane hit turbulence, rousing a wave of nausea in me. I wiped the sweat around my brows. I took out the laminated emergency-landing card and fanned myself. My head felt heavy. I needed water, but before I could signal the stewardess, I found myself throwing up in a bag. It was

just too much. Drained and relieved at the same time, I spent the rest of the flight propping my head against the window, trying to sleep.

When we finally got to Heathrow Airport, we learned we had, indeed, missed the flight to Los Angeles. My mom, Lida, Natasha, and I, along with many of the other passengers, were shuttled to a nearby hotel to spend the night.

I had always dreamed that when I left Iran, it would be a glamorous affair: Sightseeing, strolling through picturesque country villages, spending the evenings in comfy hotel rooms with oversize beds, and, of course, ordering room service. So what a reality check when—on our first night out of Iran—all four of us huddled together on the same king-size bed in a nondescript airport hotel, trying to get some sleep.

The next day, when we boarded the flight to L.A., I couldn't peel my eyes off the statuesque American stewardesses. They were all tall and thin, their flaxen hair was beautifully coiffed, and they walked down the aisles with the most graceful, willowy movements I had ever seen.

I wondered, do all American women look like them?

From time to time, scenes from the chaos of the day before crept into my mind, but I pushed them aside, instead thinking of my reunion with my beloved brothers. After some twelve hours, the plane prepared for landing. I looked out my window and was dazzled by the rows of green and yellow city lights spread out below us. At the arrival gate, we were greeted by both of my brothers. It had been four years since I had seen Jamshid. I ran to him and he picked me up like old times. While in his arms, I felt his beard pricking my cheeks as he kissed me. He still had the same smell, although I could tell he now wore a different aftershave. The last time I had seen Kourosh was a year and a half ago, when he came to visit us in Iran for the summer. He had grown into a full-fledged teenager with an Afro, Nikes, and painter's jeans. He came over and wrapped his arms around me.

"Angella, you are finally here for a visit! You're going to see our new home," he said. Kourosh and Jamshid had recently moved into a house in Beverly Hills that my father had purchased months earlier so that Kourosh could attend Beverly Hills High School. He was already in eleventh grade and had started driving. I was eager to spend time with him and meet his American girlfriend, whom he'd written me about. Kourosh took my hands. "You're going to love the new home. Just last week, Jamshid asked a rental company to furnish the place for a few months so you are all comfortable."

That temporary furniture would stay with us for months—until we realized this was not to be a short visit. That little innocent wish that I had made in the fog, rubbing on my charm bracelet, would come true.

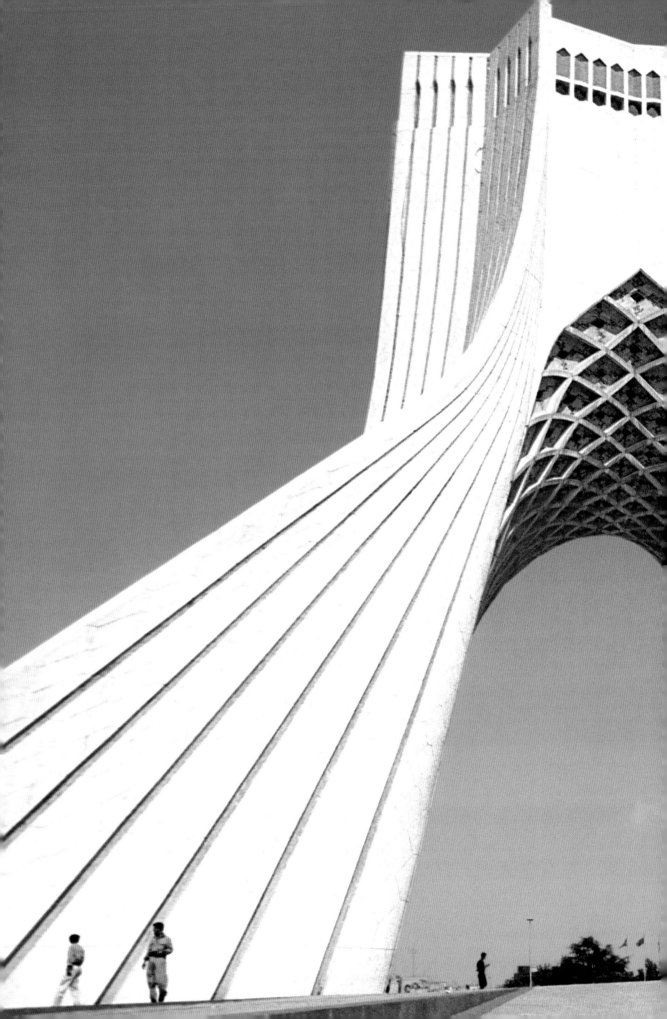

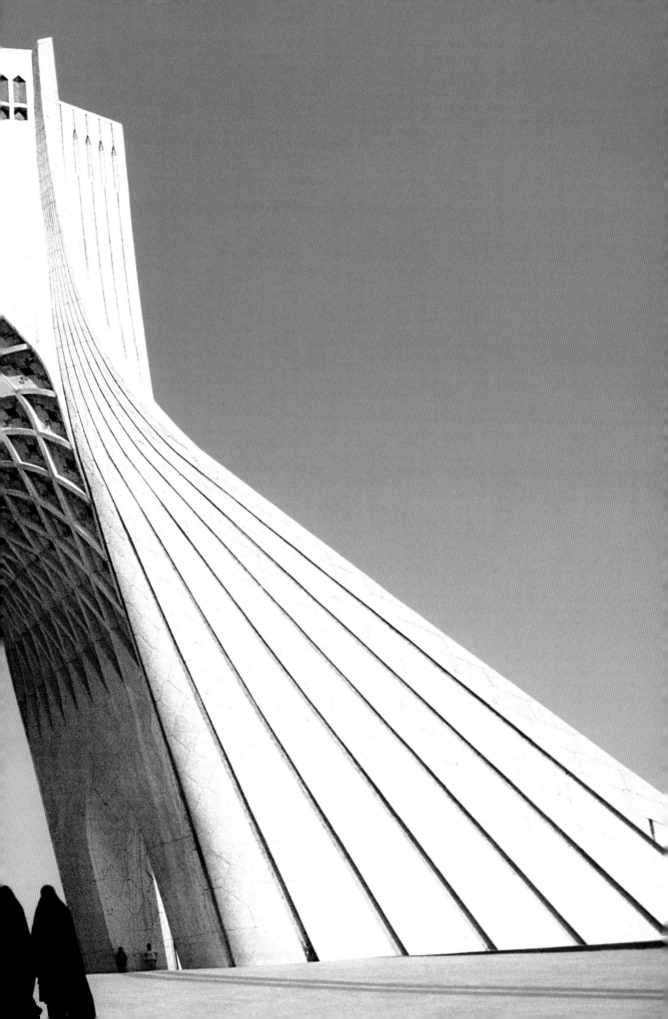

The Great Migration

 They say once you go on a safari, spending your days riding through great landscapes and prime wilderness, the vastness of the experience pulls you back again and again. They were right. My husband, David, and I, along with our two boys, Phillip and Eli, went on a safari to Botswana and South Africa. Sure enough, the minute our plane lifted off from the Johannesburg tarmac for the flight home, we found ourselves planning our return.

Three years later, we were visiting Tanzania and Kenya to follow the great migration of the wildebeests across the Serengeti Plain. It's an amazing phenomenon. The dry season and the depleted grazing plains in Tanzania lead more than a million wildebeests north to the grassy lands of the Mara River basin in Kenya. The migration is a spectacle to see—not only because of the astounding number of wildlife, but also because you get to witness firsthand the drama associated with making a migration, the exhaustion and the inherent risks and dangers of traveling in an unknown territory.

Watching the wildebeests crossing was an eye-opening experience that gave me a sense of entry into my past and what I had gone through. Wildebeests and people, sometimes we are more similar than we think, all of us on an endless stream of transitions, in constant change. Some of us cross rivers, oceans, and continents, while others face their travails in the most unexpected events of life. I hadn't anticipated these conclusions. Yet it has often been on trips, during unguarded moments when I am in movement from one place to another, that I make these connections.

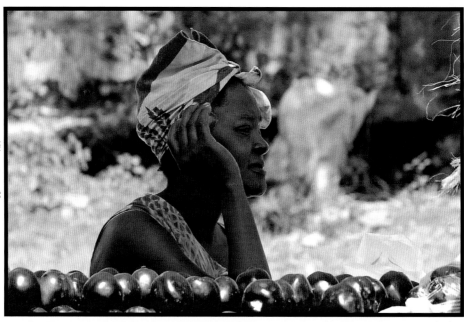

But I'm getting a little ahead of myself. On our ride in Kenya to the Mara River, Joseph, our driver, told us about how he had seen lions and cheetahs "take down" the tired wildebeests that lag behind the herd. He also said that during the migration, the biggest challenge for the herd is to cross the swelling Mara River, with its hungry crocodiles.

"So this is why we go to the Mara River, to see what the wildebeests have to go through in order to survive," he said. But he also kept warning us, "I'm telling you. Going to see the crossing is not the same as getting tickets to a show. There is no expected performance. Some days there are no wildebeests by the river. Some days there are many but they decide not to cross, and some days you will see a gory, bloody scene. So we never know."

I didn't know what to expect and didn't want to build my expectations, either. The secret to an African safari is the more delightfully you sit back and do nothing, the more you will be affected by the workings of nature. So I sat next to David in the backseat of a Range Rover, while our friends, who had also brought their two kids, were sitting in front of us, wrapped in blankets and nursing a cup of coffee. All the kids were in a separate vehicle, closely following us. On our way to the river, we chatted and joked, stopping to see herds of zebras grazing, watching a female cheetah stretch and sprint, and studying her as she got herself ready for the hunt.

During our drive, I heard Eric's voice through the walkie-talkie of our Rover. Eric was a skinny, long-limbed, acculturated young Masai who was the guide driving the kids. Joseph stopped our car and Eric's car pulled up next to ours.

The kids leaned out of the car, complaining, "How much longer? We're tired. I want something to eat."

"We are getting close," Joseph said as he handed off some bags of dried fruit and nuts. "Yesterday a large herd was spotted by the river, and I'm hoping they'll be there today, too."

I could sense Joseph was feeling the pressure, as if he had to entertain us with spectacular wildlife sightings at every turn. Every few minutes, he looked back at us through the rearview mirror. He was a short, stocky man in his fifties. Remnants of his past life as a tribesman were in clear view: A front tooth knocked out and scar tissue on his brow line that marked an initiation ritual. The day before, on our five-hour game drive, Joseph had warmed up to us and had recounted bits and pieces of his life story. What a life. He had moved out of his traditional village when he was in his twenties, trying to escape the food

shortages and deadly illnesses that ravaged his fellow tribesmen. He was a smart guy who had learned to speak English and drive so that he could become a tracker and guide at the Masai Mara National Reserve. In the years that followed, he saved enough money to build a house with his wife and three sons in a nearby modern village.

> 66 *Wildebeests or people, sometimes we are more similar than we think,*
> *all of us on an endless stream of transitions, in constant change.* 99

I was intrigued by Joseph. Indeed, I am always intrigued by people who are stuck between worlds, not fully identifying with the traditions of their culture of origin, but not completely at ease with their new identity. I guess this has also been my lot, and the lot of many Iranians of my generation who were forced out of their country and fled to the States. We never quite know which value system, which way of living, to side with, always in search of an identity that would make us feel more rooted and whole. As I looked at Joseph through the rearview mirror, I tried to imagine whether his dreams—like mine—were now in English. Or were they still in his native tongue? Did he sometimes wish to close his eyes and return to that cocoon of a well-defined, albeit restrictive cultural system—no longer negotiating who is he is at every juncture of his life?

Joseph must have felt my eyes on him, and we exchanged friendly smiles through the rearview mirror. Minutes later Joseph's face lit up. "There it is." He pointed to the vultures flying above. "That is a sign that we are closing in on a fresh kill or some activity," he said. In our days going through the reserve, we had come across fresh kills, but we had never seen a hunt. Anxiety washed over me. Would a bloody hunting scene be too intense for the kids? It's one thing to watch these scenes play out on the Discovery Channel, but seeing violence take place in real life is a different matter. "Does this mean that something is going on by the river?" I asked.

"It means that something is going on, but we don't know what yet," Joseph answered. We kept going. Fifteen minutes later, Joseph made a sharp turn. We ascended a fold in the hills, and the riverbank burst into view. He pointed across the river and turned to see our reaction.

Wow. There were hundreds of wildebeests on the other side of the river. No, thousands of them. The herd stretched as far as the eye could see. I felt the thud and vibration of thousands of hooves. Bulls in the herd made odd, croaking grunts. The kids jumped up

Following: A river runs through the fertile green Lar Valley in the southern mountains of Iran.

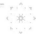

in their seats. "Tell them to quiet down, or they'll scare the wildebeests away," Joseph told Eric through the walkie-talkie. I couldn't blame them for their outburst. None of us could have imagined that staggering a number of animals.

We parked on the opposite side of the riverbank and waited for the wildebeests to cross. The herd moved along the eastern bank of the river, searching for a crossing point. Sometimes it looked like they were about to go down the slopes to cross, but the slightest sense of danger, a faint sound or movement in the water, sent the herd scurrying onto the riverbank. "The wildebeests have gone through this before. They know there are crocodiles in the water and that the slightest movement or stirring in the water agitates them. These crocodiles are huge, sometimes fifteen feet. They gorge themselves on fresh meat and live off of what they've eaten for the rest of the year," Joseph explained. The vultures circled above, waiting to pick over any leftovers from a crocodile's meal.

We were swept up in the drama of the crossing. The kids were leaning out of the car, taking pictures. I got my camera out, fastened the long lens, and took some shots of the herd. Half an hour passed and nothing happened. Five other Rovers from neighboring camps came and parked near us. Joseph kept shaking his head. "All this movement, all this noise is scaring the wildebeests. There is no telling how long it will take until they cross. Sometimes they get so agitated that they don't make a move for hours." We continued to sit and wait. One of the rovers near us left.

It didn't take long before the kids started fighting and asked if we could go back. I told them one of my favorite life lessons: "Guys, you need to be more patient. Sometimes things don't pan out according to our plans . . . but look across the river. We are lucky to see this, let's just wait and see what happens."

"Yeah, yeah. The patience thing again," Phillip said as he plopped back down on his seat. "Just another hour, okay?"

After forty-five minutes and several false starts, a male wildebeest—seemingly the leader of the pack—took charge and went down the slope of the riverbank. Once he plunged into the water, the rest of the herd rushed in, swimming furiously, jumping over the currents, and hurrying to the other side. As if on cue, three crocodiles closed in, and with a snap of the jaw and a swift jerk of the neck, one snagged the nearest wildebeest. It was unreal. There was a confused roar of sound and thrashing about in the water. We all sat back in our seats, stunned. It was so raw.

I put my camera on my lap and watched. In their frenzy to cross, some wildebeests were trampled. Exhausted, some just collapsed in the middle of the river. Some found themselves swept two hundred yards downstream by the current, only to come out of the

river to face a steep wall on the other side. There was no way out, and they trampled each other, scurrying from the killing scene. The wildebeests that came from behind stumbled and fell onto those in front. After the crocodiles had taken down their share of game, the frenzy subsided and the wildebeests that were not injured managed to go back upstream to the slope of land that led to the top of the riverbank.

> 66 *As if on cue, three crocodiles closed in, and with a snap of the jaw and a swift jerk of the neck, one snagged the nearest wildebeest. We all sat back in our seats, stunned.* 99

It was an amazing sight—nature in full swing, violence and all.

While the kids were moved by the whole scene, they appeared to be okay. They were chatting and going over the details of what they had seen. I was the one who was rattled speechless. It was profoundly humbling to be on the sidelines, watching the stampede, the chaos, and the hunt. The violence seemed random. I kept thinking about those unlucky wildebeests flailing in the jaws of the crocodiles. Being on the wrong side of the river, being too tired or disoriented, running at the periphery of the herd, or simply crossing at the wrong time had such dire consequences. I watched the trail of dust rise in our car's wake as we bumped along the rutted road toward our campsite. Here we were, in a distant, unconnected part of the world. Grass plains stretched as far as the eye could see. With each successive moment we were moving deeper into the reserve. And with each successive moment, I also felt I was penetrating an interior landscape. Everything seemed serene, but an unsettling feeling had overtaken me.

I leaned back in my seat and wrapped myself in a blanket. The scenes from the wildebeests crossing had opened the floodgates to memories and images that I had kept at bay for some twenty years. These were images of my own family's migration: Trampled bodies, people pushing past one another in commotion, police sending tear gas into the crowds, squeezing through long lines at the Tehran airport. I tend to push these scenes out of my awareness so much that at times I look at my childhood experiences in a state of disconnect. It's a defense mechanism I've developed to gloss over the challenging parts of my life in order not to feel stuck and to focus on what lies ahead. But that day, for the remaining hour in the car, those childhood images never left my mind.

Opposite: I took this picture while leaving for the airport in Mombasa.
Taxi drivers in Iran also strapped passengers' luggage onto the top of their cars, an unheard-of practice in the U.S.

My Arrival in Wonderland

 My brothers' new home was snuggled up in the hills above Los Angeles with panoramic views the likes of which I'd never seen in Iran. Each room had floor-to-ceiling windows, and on a clear day—and there are many of them in Southern California—you could see all the way to the Pacific Ocean. Every time I passed a window, I couldn't help but stop to look out and see the glimmering ocean in the distance. Back in Iran, this kind of view appeared only after a four-hour journey winding through the mountains.

The modern house had a heated kidney-shaped swimming pool, which was another real oddity. Swimming pools in Iran were exclusively rectangular, and never heated. At night, I was mesmerized by the steam rising from the pool as if it were a hot cup of tea. Natasha and I couldn't believe we could go for dips in the pool at all hours of the day—even in wintertime. The sun poured down on us even in the middle of December. In Iran, our bathing suits would have been stored in the attic and our closets restocked with the wool sweaters, boots, and thermal underwear we would need to brave the streets of Tehran, knee-deep in snow. Yet here I was, splashing in that pool even after supper. I felt like I was in a fairy-tale wonderland.

We drove down wide streets lined with never-before-seen palm trees, past homes landscaped with alyssum, lavender bushes, bougainvillea, and all kinds of exotic flowers. Tehran was dry and bare, with no front yards, and houses were never flanked by such meticulously manicured lawns. Finally I had arrived in the world that Jamshid had described in his letters. My reality was intersecting with all those captivating images.

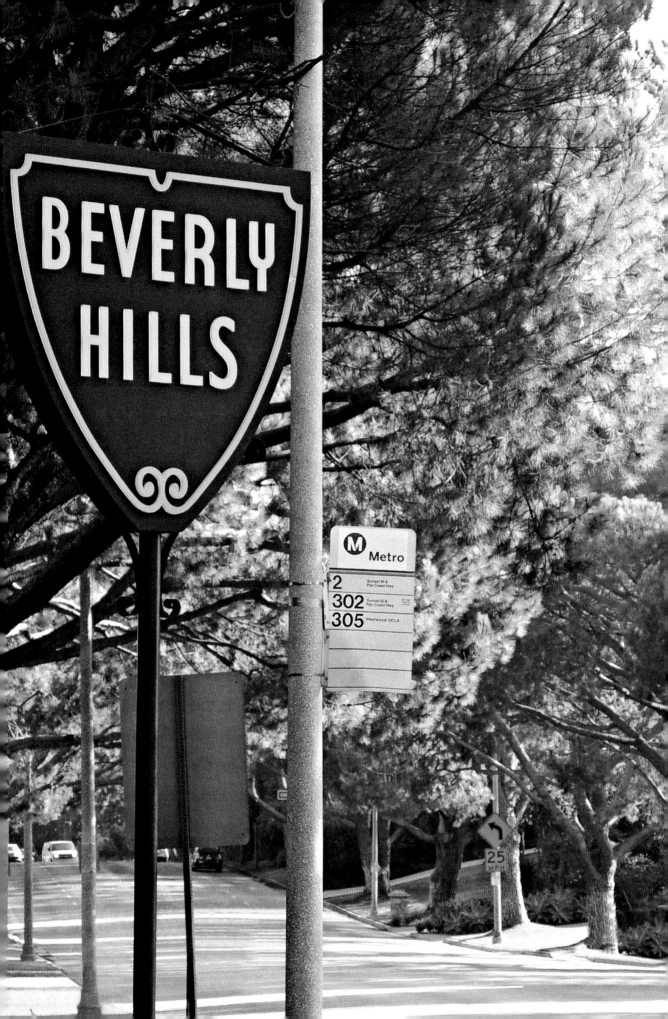

Our first grocery shopping expedition was to a place called Gelson's, a supermarket that sold strawberries and peaches out of season—unheard of in Iran. In Tehran, the local market sold just one brand of breakfast cereal: Corn Flakes. At Gelson's, there was parade of brightly colored boxes with cute names like Cocoa Puffs and Trix. Most products showed off catchy phrases that would have been alien to the shoppers in Iran. Slogans such as "New and improved," "More taste—less fat," and "20% larger—lower price" were plastered on every package. I was learning fast that in America, you could literally have your cake and eat it too.

I was used to buying snack foods from street vendors back home—grilled corn, fresh walnuts, and sour cherries in a cone made from old newspapers. In Los Angeles, everything seemed so sanitized and calm—cupcakes were wrapped in plastic, peas could be found in the frozen-food aisle, and there was no one hawking steamed beets or grilled chicken liver in the street.

The first week of our stay, we visited the Century City mall, a self-contained city of upscale shops and restaurants. The sheer abundance of fancy food and stylish clothes was overwhelming.

It seemed like I was living a double life. We spent our days as carefree tourists in this paradise of America. But every evening we were dragged back to our reality. We would gather around the television set to watch the latest news from Iran and soon found out that we were among the last group allowed out. A few days later, the Tehran airport was shut down.

> 66 *We spent our days as carefree tourists in this paradise of America.*
> *But every evening we were dragged back to our reality.*
> *We would gather around the television set to watch the latest news*
> *out of Iran and soon found out that we were among the last group allowed out.* 99

Anti-shah—and anti-American—sentiment was spreading, and religious groups were gaining more and more power. Later I read that the Iranian premier, Amir Abbas Hoveyda, was shot by a firing squad. To this day, I have vivid memories of his solemn face plastered on the front page of *The Los Angeles Times*. He was handcuffed and being led by a prison guard. The rumor was that Jews were not safe under the newly formed Islamic government. Some prominent Jewish leaders were under surveillance and were being arrested for their ties to the royal court or for spying for Israel or the United States. I was beginning to understand the true implications of the danger facing us in Iran. And I was starting to wonder if it would ever be safe for our family to go back.

After that first week, my father called and told us to extend our stay. He didn't want to alarm us, but more so, he wanted to believe that Iran was seized by a passing turmoil. "Nothing to worry about," he reiterated. "In another couple of weeks, all will be settled." Our dinnertime

conversations took on a slightly pained and worrisome tone: How are our grandparents doing, how will Dad manage on his own, how long will we be in this limbo? Still, part of me was happy that we were staying longer.

The following week, we continued our tourist adventures with the pilgrimage that all good tourists in Los Angeles make: We went to Disneyland. Looking back, I find it very ironic. Our country was in chaos, and we went to the Magic Kingdom.

We rode the spinning teacups and toured the haunted house. On our way back home that day, I had my first drive-through dining experience at a McDonald's. What convenience! Two days later, we went to Universal Studios for a tour. The *Incredible Hulk* TV show was all the rage back then, and there was a back-lot show that highlighted some of the scenes from the weekly show. We continued our distractions with a trip to Sea World, where we snapped pictures of Shamu leaping into the air.

But slowly the intoxication started to wear off. Two weeks turned into two months, and these daytime excursions were dragged down by the dark, invisible weight of uncertainty. We worried about my father, Dariush, and the other family members still in Iran. After vacillating for weeks, my mother decided to return to help my father sell some assets.

Before buying her tickets, my mother asked if I wanted to go back to Iran or stay with my brothers and Lida. I did not hesitate in answering: I wanted to stay.

I wonder why she asked. Did she feel bad about leaving me with my siblings? Or was she worried she would have trouble getting back? Was it safe to bring me back to Iran? I'm sure she was torn.

In the end, my parents decided that I would continue my sixth-grade studies at Hawthorne Elementary—an idyllic, friendly school with colorful murals on the walls, green grass in the yard, and an indoor gymnasium. Although the staff was cordial and tried to help me fit in, it was here that I first started to really feel displaced. I missed my childhood friends deeply, along with my cousins and the other familiar faces I had grown up with.

I missed my own school in Tehran and the comfort of my bed. I felt uprooted. I had come with only one suitcase. The things that gave me an identity—my books, my dresses, my journals, and my baby pictures—were all neatly organized in my closet back home. As the weeks passed, Lida helped me shop for more and more clothes at strange, cavernous stores like the Gap. The proportions of stores in America were so different. The variety, too, was mind-boggling.

Months passed, and eventually we returned the rental furniture. There seemed to be no turning back, and each new purchase rooted us more firmly in our new life in Los Angeles.

THE JEWIS

OF GRE

Volume 23, Number 29 •

Escape, Ex

H.JOURNAL

JOURNAL

ANGELES

11, 2008 • jewishjournal.com

le, Rebirth

Nectar of Life

I ate so many peaches today.
Four or maybe five
at the fruit stand across from the sausage vendor
and the cheese shop

in the streets of **Lugano**.
I wasted no time.
I sliced the fruit against my finger in front of the store
and tasted

the months of **Mediterranean sunshine** and rain

stored in its **yellow** juice.

There are plenty of counterfeit offerings
back in my big fancy world
of palm trees, cashmere socks, and thousand-thread-count sheets.
On steroids and buffed,
these stunt doubles are placed neatly at an angle
against each other
to form a shining pyramid
under fluorescent lights.
I wonder if their agents tell them
their left side is their best.
It gets to me now and then.
But **peaches and mulberries** leave me
with memories of
summers in my backyard
panting and jumping rope.

The branches of the neighbor's mulberry tree
hung low with fruit
on our side of the yard.
My brother,
the one who cut the whiskers off neighborhood cats
to watch them fall off walls,
would climb and pick
a week's worth of mulberries for us to eat.

I wonder who's eating those mulberries now?

Even then I knew,
without knowing I knew,

that **sleeping on the rooftop** on balmy Caspian nights
where small breezes bent fragile grass,
myself adrift, flung heavenward,
and waking up to

fresh mulberries and peaches with yogurt,
days spent in worship of play,
all pure and simple,

was the **sweet nectar of life.**

I wonder who's sleeping on the rooftop

and gazing at **stars** now?

I will wait for the unrisen stars
in Switzerland tonight.

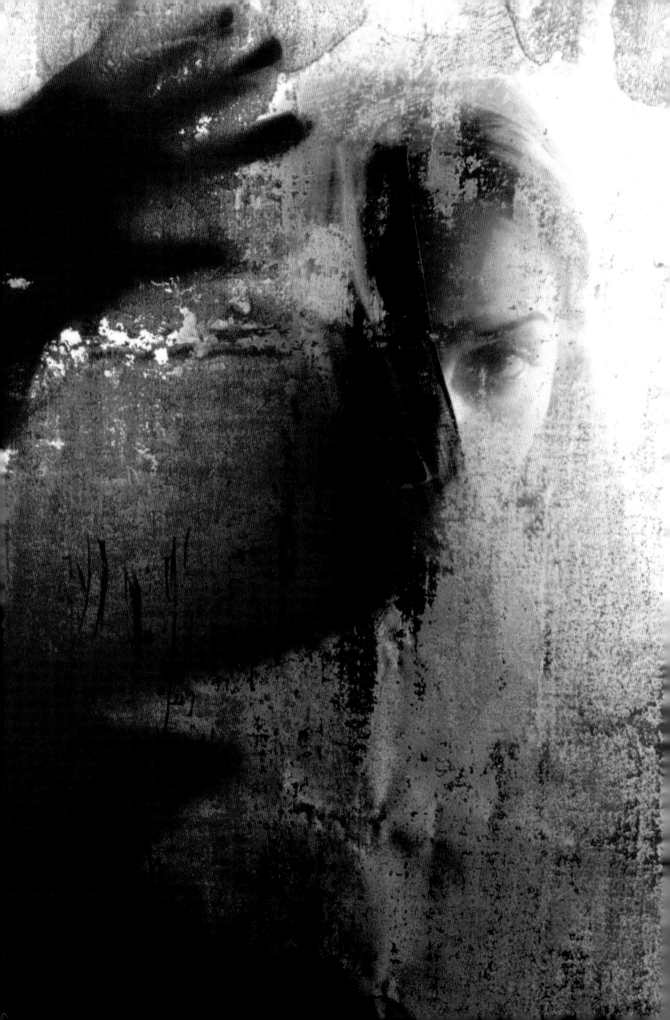

Outside, Looking In

It is one thing to come to a place as a tourist, and quite another when circumstances force you to stay. As tourists, we descend on a culture that is not our own and pick and choose dazzling places and activities for our short-term entertainment. I call this "window-shopping." Obviously, becoming a resident means fully immersing oneself in the daily rhythms of a country. That was a tall task for a sixth grader—to create a community and a sense of belonging in my new host country. Once I really began talking with the other kids at my new school, I realized how out of place I truly was. I was an outsider.

As any immigrant will tell you, the biggest problem at first is simply the language barrier. I felt like I was in speech-delay mode, constantly translating from Farsi to English when I wanted to say something. When I wanted to study, I had to leaf through a thick dictionary by my side to translate everything. Still, I was one of the luckier Iranian students; many came to school without speaking a word of English.

Like most eleven-year-olds, I was eager to fit in and desperately wanted American friends. But I had the extra burden of being from a country whose people were called hostage-taking barbarians by President Ronald Reagan. Graffiti all over Los Angeles, even in the bathroom stalls at my little school, read, "Iranians go home." In a city of "angels" that normally welcomes people from all over the world, we were not, to put it mildly, the preferred immigrants of the day.

If we were asked, "Are you Iranian?" by a stranger, our response was almost always qualified. "Yes," we would say, quickly adding, "but we're Jewish."

In heavily Jewish Beverly Hills, we thought this might help us fit in. I saw this response all the time, not just among my family or other sixth graders. Our whole community seemed to want to distance itself from our native land—at least temporarily.

Suddenly Iran was a four-letter word. Indeed, this continues for some, even today. Asked their background these days, many in my community will say "Persian" rather than "Iranian," referring to the days of our glorious empire, known for its civil rights, poetry, and sophistication. I know this confuses some of my geographically challenged American friends. Sometimes, when I say I'm Persian, people reply, "Oh . . . what part of Paris are you from?" They think Persia is tucked away somewhere near Belgium. Others, I am sure, wonder why we are veiling our roots.

It was around this time that I started to feel very uneasy about being Iranian and began a lifelong struggle to find a place for myself where I felt accepted. This was a period of transition. It felt like I was leaving harbor—I no longer had the safety and the anchor of where I came from and even less of an idea where I was going.

So I settled into a different life, and was very conscious about doing things in an "American way" to compensate for my otherness. I noticed that there was a certain "fresh off the boat" look and manner that incoming Iranian girls had: They wore skirts instead of jeans, they wore stockings and party shoes instead of sneakers, they didn't style their hair, they brought food from home instead of eating in the cafeteria, they never participated in after-school sports, they never raised their hands in class, and they looked down while they walked through the hallways.

But I caught on fast, in part because of my family situation. While other youngsters would speak Farsi at home with their parents, my mom and dad were still back in Iran. So at my house, my siblings and I spoke only English, peppered with some familiar Farsi phrases. My surrogate mom, my sister Lida, was only twenty-six years old, and our household was younger and more malleable than most. This helped me, and I learned to speak English with only the slightest accent.

I became a straight-A student and often helped my classmates with their chemistry homework after school. I joined the basketball team and made American friends, mimicking their expressions. The first thing I observed about the American way of speaking is that it uses the word "love" for almost everything. "I love cookies," "I love that dress," "I love to play basketball." In Farsi the word "love" is used only to speak of your affections for a spouse, not even your friends or parents. It was strange to love a cookie or a dress, but now I said it nonetheless.

Preceding: Photograph from the series *Be Colorful*, by Shadi Ghadirian, C-print, 2005.

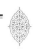

"Wow, that's awesome!"; "That grosses me out!"; "Are you putting me on?"; and "Like I care" are other phrases that have no direct translation in Farsi. But these were phrases that my friends would sprinkle into their conversations all the time. So naturally I did the same to blend in.

My daily routine called for me to be dropped off by the bus at school at 7:20 in the morning, and I would wait outside the library for my friends. One morning, as I came out of the girls' bathroom, I overheard two classmates talking. Anne, a boisterous and funny girl, was leaning against the glass entry of the library, while Ellen sat cross-legged on the tile floor next to her backpack. I caught the tail end of their conversation.

"You know, I'm surprised—that Arab girl is really sharp. She helped me with balancing those equations in science last week," Anne said.

"Yeah, Angella is pretty smart, I guess," Ellen replied. "I was supposed to meet her here today. I wonder where she is?"

I froze by the doorway of the bathroom, stunned. I was "that Arab girl" to her? I closed the bathroom door and stayed there until school started. I was hurt and angry that she had lumped Iranians in with Arabs. We Iranians are not considered Arabs; we don't even speak Arabic.

"I am not Arab, I'm Iranian. And my name is Angella" were the words reverberating in my head that day.

Sometimes the insults were more subtle. Despite my best efforts to fit in, I was always brought down a peg or two by careless comments. Sometimes, when my friends wanted to give me a compliment, they'd say, "You're not like the rest of the Iranians."

Such a comment was typical of the double bind I found myself in. I knew it may have been well intentioned, but I was not sure comments like that were even compliments. Once again, I understood that the images that Americans held of Iranians were not flattering. And although these comments made me feel even more self-conscious and alienated, they also gave me a sense of false superiority over my less-acculturated Iranian friends.

By the end of seventh grade, teachers and administrators had coined me as a model foreign student who had successfully integrated into school and social life. I managed to be an honors student and was also invited to most of my classmates' bar and bat mitzvah parties, to which none of my Iranian friends were invited. Hardly any of the Jewish Iranians, including me, had the luxury of marking or celebrating our thirteenth birthdays with a bar or bat mitzvah. Going to after-school Hebrew classes or organizing a party was not at the top of any Iranian's list, not while families were still grappling with acclimation and day-to-day challenges. As well-adjusted as I appeared to be, I struggled with my emerging identity. I felt a subtle form of emotional distance from both my Iranian and American friends, not fully identifying with either group. I felt as if I were caught between two worlds.

Istanbul

That day in Istanbul

that day when I slid in the back of the taxi

with my children,

I said I was Iranian and **not American,**

fearing the cab driver would take offense.

I was right.

You Iranians will teach those

bullying, pork-eating, Jew-loving Americans

a good lesson.

It's all about Jewish money, you know.

A barrage of ugly words

spilled through the **smoke**

from his cigarette-clenched teeth.

Phillip's bright eyes went wide with fear.

There was no trace

of his perennial teenage cool.

Eli clutched my arm with one hand

while the other had a firm grip on the door handle.

It was elementary math:

This man hated all but one-third of me.

I assumed this meant that

those Jews

who had not made it big

who were not chest-deep in cash,

shoveling money,

were at the receiving end

of a major cosmic letdown.

And Americans,

they were

a **misfed and misguided** *bunch.*

I suppose I had a right to say something,

to set things straight.

But I didn't hear my voice

rise up in opposition.

I was playing the game again:

a chameleon taking on

the colors cast by its background.

woven his way
through the busy streets of Istanbul
on a kamikaze mission
to drop us in a landfill,
most likely on the outskirts of town.

He could have made David wait,
having him calculate the time it takes
to come back from the spice market
a thousand times in his head.
Or that's what I thought.
That day,
the cab ride in Istanbul marked the first time,
the first time my children overheard
someone talking behind their backs.
Only difference was
they were in on the conversation.

My childhood friend was right.
She's wickedly funny between her crying spells.
She laughs and tells me
my initials should change from A.N.
to U.N.—
unidentified nationality instead.

I kept still during the ride.
I knew the driver's eyes,
then full of kinship and care,

could hold an avalanche of rage
in their place.
He could have made a **left**
instead of a **right,**
could have driven past the Blue Mosque,
and the old bazaar,

Hands folded on my corduroy skirt,
I let out a shallow breath.
I strained to look out the window.
My faint **reflection** glared back at me.

Spotting Marie Osmond

The summer I was thirteen, I began to question the glaring discrepancies between my expectations of American life and the reality presented to me. In the eighteen months I had lived in Los Angeles, I had noticed how Americans' perceptions of the Iranian immigrants were colored by the alarming images being broadcast on the news: Images of gun-toting, enraged men running hysterically in the streets, burning the American flag. I knew those images were not a full representation of Iran and its culture. But just as Americans had judged us wrongly, I, too, had made sweeping, inaccurate assumptions about them based on the sitcoms I had watched in Iran. I soon discovered that Americans were no more courageous or happy than their Iranian counterparts.

This epiphany came one sweltering Thursday afternoon two weeks before the start of ninth grade. Lida dropped me off at Beverly Hills High School to register for my classes, and later I planned to walk a couple blocks to Century City to meet up with Lida, Natasha, and her little brother, Jonathon, who was now two years old. On my way to the mall, I spotted some pink flyers strewn all over the high school's driveway and sidewalks. The big, bold letters screamed out: "Lucie Arnaz, Lucille Ball's daughter, talks about substance abuse and her parents' divorce."

I couldn't believe what I had just read and had to fan myself with one of those flyers. The one and only Lucille Ball, who lived just up the road in Beverly Hills, had a daughter with substance-abuse problems?

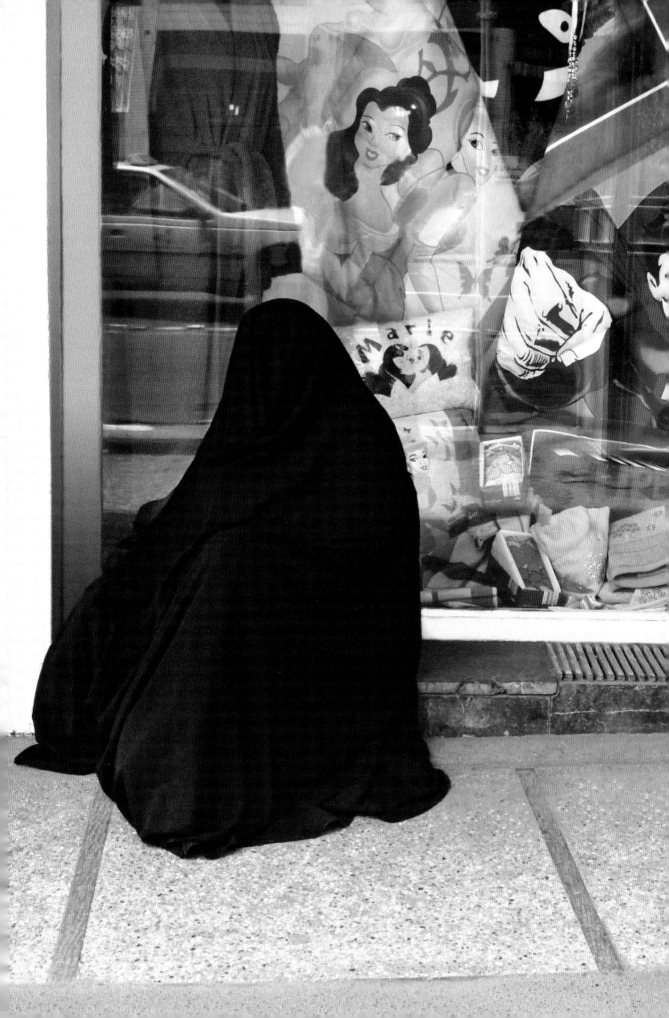

Behind the veneer of a happy family life on TV, Lucille Ball's family also struggled with marital strife and unhappy endings. This is not what I had picked up in Tehran.

That very same day, while rummaging through the towels in the linen department of the Broadway department store, I spotted a nice-looking young woman shopping for bathrobes nearby. It was Marie Osmond. This was nothing less than a surreal moment for me; I had been plucked out of Iran just a couple of years ago and was now standing near my childhood idol.

I put my head down and casually walked around the table stacked with colorful beach towels to get closer to her. She was wearing black trousers, a simple T-shirt, flat shoes, and no makeup. I was struck by the ordinariness of the situation, her lack of glossiness, which betrayed my image of her. She seemed shorter in person, and I was deeply disappointed she did not measure up to the glamorous image I had in my mind.

> 66 *This was nothing less than a surreal moment for me; I had been plucked out of Iran just a couple of years ago and was now standing near my childhood idol.... I was struck by the ordinariness of the situation, her lack of glossiness, which betrayed my image of her.* 99

This encounter was pivotal to my understanding of how I was influenced by reductive, simple images. Sometimes, even now, I automatically perceive strangers, especially people from other countries, by what I've been fed through the media, which inevitably leaves no room for them to be seen as who they really are. These snap judgments are not just reserved for others; even now I catch myself wanting to fit a certain one-dimensional image of either a traditional Persian Jewish woman or of a modern Western woman. At least that would relieve me of the burden of constantly trying to reconcile the incongruous value systems of the East and the West. Should I be a model homemaker, mother, and wife? Why do I feel guilty about wanting to work or do things outside of the home? Am I less feminine for being more assertive and independent? How much time should I put aside in service to my extended family?

I don't seem to fit into a scripted category, and that has come about through the conscious cultivation of a sense of ease and belonging within myself, as an individual with idiosyncrasies, regardless of my religion, race, or gender. Traditionally in our culture, the mark of a good woman has been her ability to keep a good home, raise good children, and

Preceding: Woman in chador sitting by a shop selling Western-style clothing and goods. *Opposite:* Excerpt from the lyric poet Hafez-e-Shirazi: We have come to this door, not for pomp and position, / But because of ill fortune, we have sought shelter here.

support her husband, and this is especially true if she is from a well-off family and has no need to work outside the house. But from a young age, I idealized my brothers' and my father's value of education. The fact that I excelled in school only fueled my desire to go to college and to find a meaningful career for myself. But I did not have any immediate role models in my family. As a matter of fact, I am the first woman in my family who has earned a college degree. That I spent my most formative years in the United States without my parents encouraged me to be a more independent and self-starting person.

At times, I still feel uncomfortable about my independent streak as compared with the characteristics of a typical Iranian woman. My childhood passion for travel has been the ideal vehicle for growth because it has exposed me to models of possibility other than those I grew up with. Through these diverse experiences, I have developed more expansive ways of relating to the world and, most importantly, to myself.

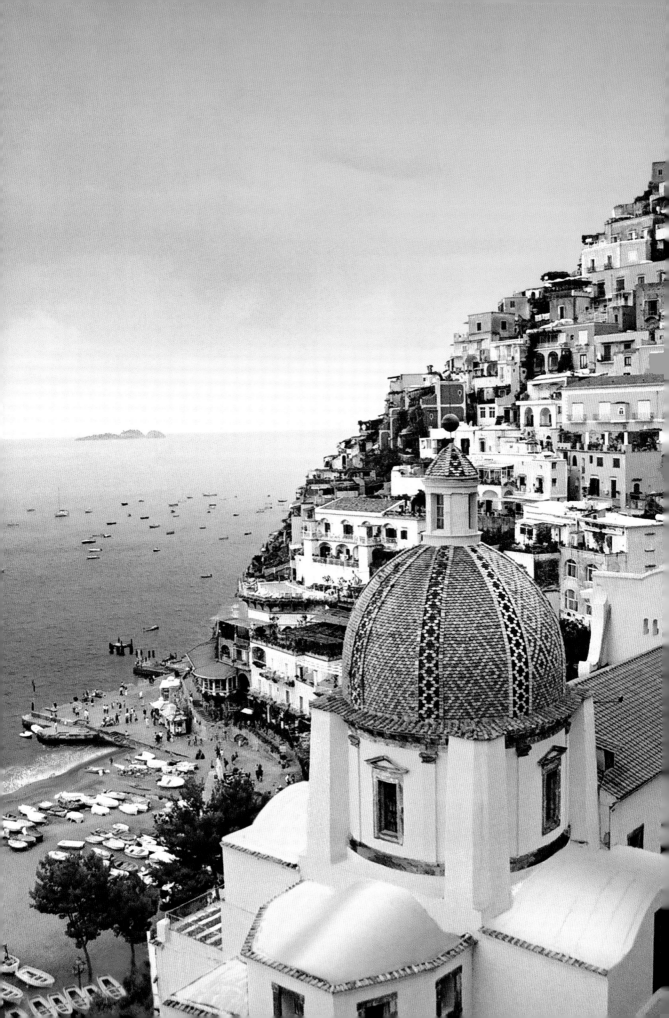

Double Ds in Positano

 I hear their echoes bouncing off the Italian mountain. They find their way through the cracks in the walls. I go downstairs to fetch my bathing suit and catch sight of the delicate blues, yellows, and greens of the mosaic church dome a short distance away here in Positano. I hear the sirens calling, but disregard them.

Upstairs I sit on the terrace by the pool at the Le Sirenuse hotel. I lay a towel on a chaise and sit down to read my book, distracted by the laughter of two teenage boys splashing each other at the opposite end of the pool.

A fiftyish woman drifts aimlessly on the other side. Her breasts bulge out of her swimsuit as if each had its own zip code. I'd never seen breasts float like that. You can tell even from here that she has implants. Unbeknownst to her, the boys keep glancing at the double-D flotation devices lodged inside her chest. Her lips are swollen and her eyes are pulled tight to the sides of her face.

She comes to dry off next to her bookish twenty-year-old daughter and slips on a lime green T-shirt with bold letters screaming out, You Look Like My Next Boyfriend. I think to myself that she is going full speed in reverse on a one-way street. But I know these are the judgments I make when I don't want to take a good look at myself. I can tell that she has sirens running wild in her mind, telling her she needs to be a better version of herself—I have them, too. My sirens, though, pester me with secondhand opinions of who I should be on the inside.

I need to be a cookie-baking, Mary Poppins kind of mother who breaks out in song and dance when overwhelmed by responsibility. Also, I must be seen as a person of substance and intelligence, with deep opinions about world affairs.

The image of Condoleezza Rice comes to mind—and while I am at it, I would like to play piano like her. I would like to volunteer for the Peace Corps, but then again, I don't know if Mary Poppins or I could spend a year sweating and swatting mosquitoes in the jungles of Nicaragua. Of course, I also want to exude an aura of perennial fabulosity and outer chic while going about my day. How can I be all these things all the time? When I was in my teens or even my twenties, I used to think that my angst over my sense of identity and who I want to be was because of the discrepancy between the ideals of my traditional culture and those of the Western culture to which I was adjusting. This may have been the case at the time, but what about now? At this point the responsibility of shaping who I am rests on me and my choices. And truthfully, some of my habits of thinking do nothing but keep me stuck, like sirens clouding my judgments.

I admit it. I have become a self-improvement junkie. Just last week I was talking to my good friend Elizabeth about my predicament. "Angella," she said, "maybe our real goal in life is not to change, but to let ourselves be who we really are." She always says things that stop me dead in my tracks. Without intending to, she often clears up so much for me. An Iranian Jew, she too came to the States when I did, and at the same age. We seem to have many experiences in common, which adds to the richness of our friendship. This time around, her comment made me pause for a minute or two. This was a revolutionary idea, and it seemed to set off a tuning fork in me. I felt it in the pit of my stomach. Here was a novel way of approaching myself: Instead of reaching for that impossible ideal, I need to give myself permission to follow what my deepest nature asks me to be, even if the results are at times flawed. I don't always have to censor moments when I am lazy, upset, tired, or even selfish. Those uncomfortable feelings are also part of the real me and who I am at that moment. Truly, it would be a great shame to have that realness in me, the good along with what I judge as insufficient, be a mere visitor in my life.

I turn my head and see a group of little girls splashing about in the shallow end of the pool. They giggle while trying to choreograph some kind of synchronized swimming sequence. I reflexively think about the times I used to play in the alley in front of our house in Iran when I was their age. I used to play hopscotch and hide-and-seek with two sisters who lived next door. Narges was two years older than I, and her sister, Nahid, was a year younger. I also remember how frustrated I would get with Narges. Being older and more manipulative, she would change the rules in the middle of the game to suit her own needs. "No, this time around, we aren't supposed to tag each other. And so I am not *it*," she would say. Or she would declare

in her bossy voice, "Nobody really wins this round of hopscotch. It is going to be two out of three." At times, I would refuse to play along and stomp off to my house; other times, I would keep arguing with her. Looking back, I think I was just plain jealous of her—jealous that she had the guts to change her mind or change the rules as it pleased her. Even now it would be such a liberating experience to tell myself that I'm changing the rules of the game, that there are no set ways to be. Wouldn't that kind of redefinition really help me break free from that guilt ghetto of the sirens' song and open my life to a radical new set of possibilities?

I take a deep breath and feel the salty air fill my lungs and tell myself that I did not fly all this way and make hairpin turns through the mountains on the Amalfi coast just to read a book. I sit up and put aside the book on my lap and turn to the double-D woman, who is now sitting close by, applying sunscreen to her shoulders. We exchange a glance, and I smile. A hummingbird hovers in the air in front of her and jets off behind me toward the sea. I turn my head to follow its movement. My eyes drift down the cliffs that rise abruptly from the beach and to the fishing boats resting by the shore. There is a comforting rhythm to the waves. They rise and swell, demanding full attention, only to subside to a faint whisper. I watch the interplay of sand and water in a cavernous outlet beneath the bluff. The incurable scavenger, I remind myself to scour the beach to find the right kind of pebble to take home from this trip. It will join a menagerie of found objects from my travels: The gray piece of driftwood from the Sea of Cortez that sits on top of my dresser; the nautilus shell that I found on the beach in Marbella in southern Spain on my vanity table; the ecru-colored river rock in the shape of a heart from Chiang Mai, Thailand, that I use as a paperweight; the piece of white coral from the Great Barrier Reef in Australia, next to my soap dish; and the camellias from Punta del Este in Uruguay, pressed and dried in the middle of the book I am reading by the pool, aptly titled *The Art of Happiness*.

Next to the glass ashtray on the table by my chaise is a matchbox with the hotel's logo on its cover. I hold the matchbox in the palm of my hand and study its details. Two mermaidlike sirens lie on their bellies across from each other, their tails high above them like a canopy, their arms outstretched, holding a hurricane lantern between them. The two nymphs with flowing hair float on the beige background of the matchbox. Below them, Le Sirenuse is printed in gray ink. No, not a pebble: this is the souvenir I will take home with me to remind me of this moment.

I open my palm. I rub my fingers along the sandpapery edge and drop my head back and close my eyes. I feel the warmth of the sun against my skin. Red lights swirl behind my eyelids. The siren's song is faint now, barely audible. I put the matchbox in my straw beach bag. I tell myself, "I am free to change the rules once in a while." Because in the end, it is when I'm constantly trying to be someone better than myself that I'm far from home.

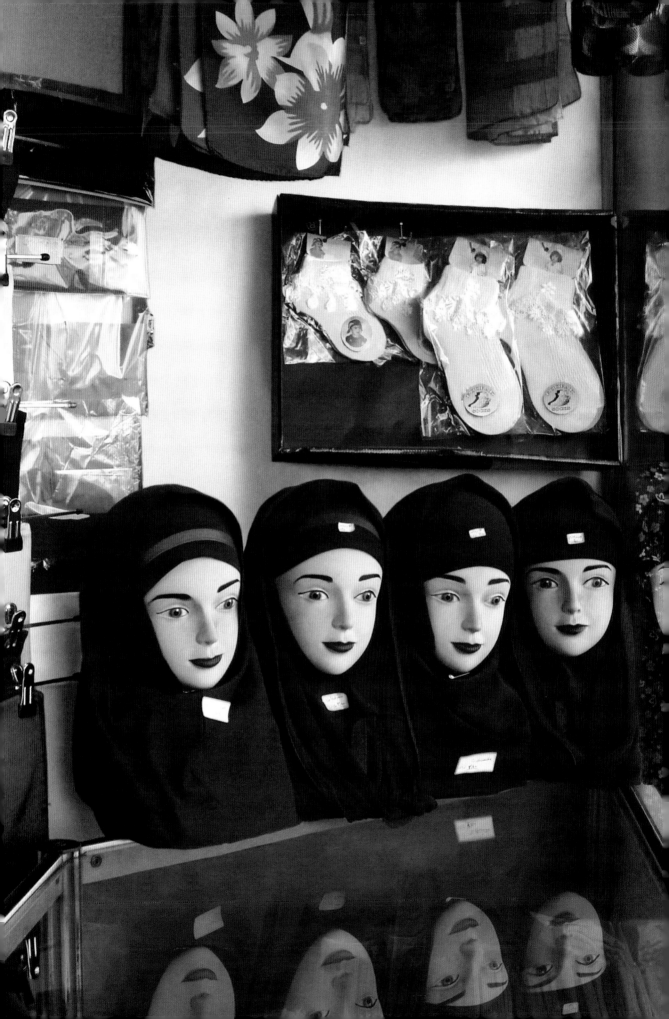

The Immigrant Mentality

 Aside from the constant worrying and praying for my parents' return, I had other fears that I kept inside. I was too embarrassed to ask Lida or Jamshid how much we had in our savings account, so I worried we were running out of money. I felt guilty that my sister had been relegated by default to the role of mother. Now she had to take care of me as well as her own two kids. Lida's husband, Behrouz, had joined us in L.A. after the birth of their son, Jonathon, and was forced to start his professional life all over.

Although he was more than qualified to work in Iran, Behrouz had to pass the state board exams in order to practice medicine in California. I remember sitting with my niece and nephew in the backseat of our brown Oldsmobile while my sister dropped him off to study at the UCLA biomedical library. My sister has always done what's right, even at great personal cost. Because she was the only adult female in the house, she spent most of her time tending to other people's needs. At age twenty-six, when most young women are just settling down, Lida had already mastered the art of multitasking. She kept the house in order, shopped and cooked for eight people every day, kept track of my comings and goings, and always included me in her weekend outings with her kids. Meanwhile, she and her husband were struggling to reestablish their own life in a new land as well.

Knowing how hard it was for all the adults around me, I tried to keep my needs in check. I became more independent and self-sufficient, traits that have served me well. I started shopping for my

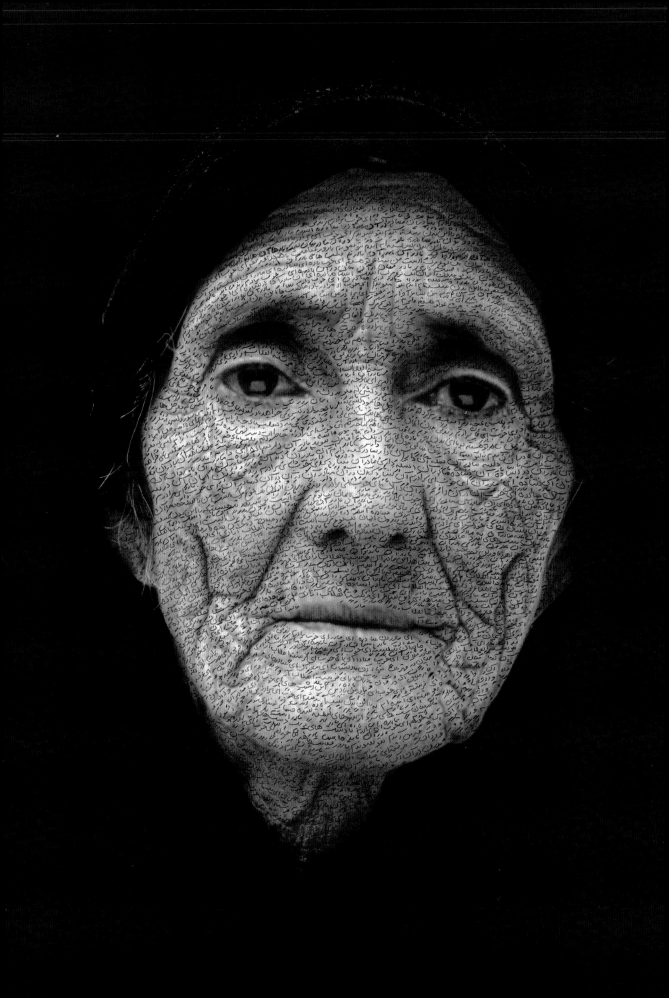

own clothes and organized my own rides to my after-school basketball games. Since no one in our family was familiar with the nitty-gritty workings of American schools, I had to figure it out myself. That meant learning how to apply for my school's honors program, as well as trying to navigate the maze of college-prep courses.

I think we were better off than many other Iranian immigrants. We were young and had a lifetime to adjust to our new circumstances. Infinite opportunities lay in front of us. Those who were well into their sixties or older had the toughest time. They were the ones who had spent a lifetime saving their money for their old age, only to leave everything behind in their disinherited country. Here they were hemmed in—their options narrowed by old age and language problems. Their failed attempts at business were only a foretaste of the years of struggle ahead. These people, understandably, spent most of their time looking back at their youth and glory days, for ahead of them things only looked worse.

There is a man, now in his seventies, who has had the same run-down store along Westwood Boulevard, near UCLA, for the past twenty years. He sits in his modest shop from early morning until late evening, selling dried fruits, nuts, and Persian ice cream infused with rosewater. A framed picture of him—elegantly dressed in a suit and tie with a dignified, almost regal demeanor—hangs on the wall behind his register. Every time I visit he makes sure to point to his picture as he stuffs my dry goods into a plastic bag. "*Khanom* [Miss], don't look at me like this behind a cash register. I used to be a person of substance." He doesn't realize that he still is one, even behind that register, stained clothes and all. It takes great courage to start over, to press on, so late in life—even if we fail.

There were plenty of Iranians in America who felt defeated from the start, as if they were cheated out of life. Oddly enough, they held on to misery because it was the most familiar and predictable thing they knew. Their features, especially their eyes, showed telltale signs of sadness and resignation. Their expressions were vacant and devoid of spirit, as if they were awaiting a life-changing event that never came. These were the common outward indications of the weariness and pain of those whom exile had claimed.

I understand their challenge, a challenge that waves of other immigrants from other lands have all experienced in America. Many of their generation were simply too threatened by the onslaught of change. To cope and protect themselves, they invested their energy in smaller and smaller islands of familiarity. Like shellfish that open and close their shells on the tide's schedule even when transplanted to a tank, many in the Iranian immigrant

Preceding: Shirin Neshat, *Zarhra*, C-print and ink, 2008 *(left)*; *Haji*, C-print and ink, 2008 *(right)*.

community went about their days in their new environment according to old rhythms. There were men who dressed up in suits and ties early in the morning, with no place to go. These men congregated at the ocean-side park and walked briskly, hands clasped behind their backs, heads bowed.

Iranian women my mother's age drove daily to Persian specialty markets that had the familiar smell of herbs from the faraway homeland. These women pushed their carts past one another through cramped aisles, chitchatting with friends and acquaintances. Going to the market is a casual activity for most people, but shopping in a Persian market carries the extra weight of maintaining appearances under social and public scrutiny. Like any group of immigrants dedicated to adapting and becoming successful in a new land, many women guarded their family image by dressing up, donning expensive "I've made it" handbags and fine jewelry for their shopping excursions. They made sure they were nicely groomed, as if a misplaced hair or an untucked shirt were a sign of a fractured life.

> 66 *Like shellfish that open and close their shells on the tide's schedule, even when transplanted to a tank, many of the Iranian immigrants went about their days in their new environment according to old rhythms.* 99

These are the contradictions of a people for whom nothing seems to be in its rightful place.

Fast-forward twenty-five years and you have my generation. We are a proud bunch. By any standard, we are one of the most highly educated and successful immigrant groups in the States. Our lives are far better than what we would have faced in Iran. But underneath this success and these beautiful homes, there remains a deep and often unrecognized sense of insecurity. We call it the immigrant mentality. Others may have a hard time seeing it in us, but it's a low-grade affliction. And those who have it are quick to detect it in others. We are not at ease with ourselves. We are consumed with looking ahead, trying our best to secure the conditions of our future happiness, as if we can never truly relax and feel like we have arrived. There is always a possibility of impending, unforeseeable change that will overturn our fates' benevolence. But isn't that the baggage that every striving group of immigrants brings to this land? An insecurity and an overriding need to achieve, to prove that they are worthy?

It has taken a generation for us as a community to settle into our everyday life, to allow ourselves to feel less guarded and self-conscious. I'm still not sure we are all there yet.

Interrogations & Incarceration

All along, my parents had envisioned that they would emigrate to the States in six months. But six months turned into almost six years. It was a difficult time for the whole family. My parents' calls to us were short and their speech veiled, because they feared that the government was listening in. I didn't get to talk to them much on the phone—those precious calls were saved for my older siblings, who needed help with pressing family matters. My teenage-girl questions, after all, were always the same. "When are you coming back? Will you be here for my birthday this year?"

The growing volume of their absence began to weigh on me. Birthdays were especially hard. When friends and family gathered to sing "Happy Birthday," I was reduced to tears.

All the Iranian kids I knew in school had at least one parent living with them. I was reminded of my parents' absence every time a paper was sent home to be signed by a "parent or guardian." My eighth-grade graduation came and went without them. What should have been a normal "parent-teacher conference" brought a deep sense of sadness for me.

Mother's or Father's Day celebrations—forget it.

Every year another unfortunate event would delay their arrival. First they wanted to arrange for my brother Dariush's safe transit. He came in the spring of my eighth-grade year. Then they got stuck in the middle of the Iran-Iraq War, with its food rationing, power outages, and endless nighttime shelling. My mother reported that once-typical grocery outings had become scavenger hunts, with long lines of women

queuing up for staples like milk and eggs. The guilt I felt for living in Beverly Hills was growing and growing. In one phone call, she told us how the Iraqi embassy, near their house, was bombed and pieces of cars were scattered in the backyard. All of the windows of our old house were blown out.

Later they couldn't leave the country because my father's passport was confiscated. My father, like many Jewish businessmen at the time, was experiencing intermittent trouble with the authorities over immigration issues. They believed, of course, that if my father left, he would never come back. The authorities suspected that everyone with means who had relatives abroad would want to relocate to be with their families. At one point, his passport was stamped "No Exit." He was not allowed to leave, even for medical attention abroad. But he was also under suspicion from other government agents because the authorities knew he had transferred a large sum of money to the U.S.—money that was used to buy a house and support his children. The secret police had interrogated him for sending over this money.

> ❝ *My mother reported that once-typical grocery outings had become scavenger hunts, with long lines of women queuing up for staples like milk and eggs.* ❞

My mother told me how my father was carted off to the police station in Tehran for an "interview" and how she insisted that she go along, against the orders of the police. She wanted to make sure she knew where he was because so many men would disappear after those interrogations.

My father played it cool. He did not seem intimidated by the endless questions. The police had found a ledger from a rug dealer who exchanged currency on the side and who had my father's name listed on his logs. This man had been helping my father transfer money to the States.

Although my parents were separated at the station, they both gave the same story. They did not deny their interactions with the carpet dealer. And they both reassured the police that their home was in Iran and that they had no intention of leaving. "We are not young. We have built our life here," my father said. The money transfers, he said, were to support their children, who had been sent abroad only to attend good schools.

For some reason, which remains unclear even today, this seemed to satisfy the

authorities. My parents were allowed to go home at one in the morning, after a stern warning that more questions were certain to be forthcoming.

From then on, my parents were always afraid they were being watched. Every unexpected phone call or knock on the door became cause for concern.

> 66 *The Iraqi embassy near their house was bombed and pieces of cars were scattered in the backyard. All of the windows of their house were blown out.* 99

The tipping point came with the arrest of my mother's brother. My uncle Nasser had been a high-ranking official in the shah's government. His lofty title—deputy General manager of industry and mining for the Bank of Iran—gives only a hint of his influence during the shah's regime. He was also dispatched to troubleshoot problems at Iran's failing national paper-manufacturing concern.

While in these important jobs, my uncle developed a loyal following among his employees and colleagues. Indeed, when employees from the firm came to my uncle with tales of how they had been tortured, he took action. It seems that a collaborator for SAVAK, the shah's secret police, was working among them and informing on some of these workers. SAVAK was notorious for questioning and punishing anyone who said anything that was remotely against the shah's government. Although my uncle was a supporter of the shah, he felt that the tactics of this secret agency were especially subversive and demoralizing to his employees, and so to guard their safety and security, he fired the mole.

But when the revolution came a year later, it was time for payback. This collaborator switched camps and became part of the Revolutionary Guard. Now that he was in a position of power and authority, the former SAVAK informant wanted to take revenge for being fired by my uncle by blackmailing him for $30,000. My uncle, an honorable man, balked, so this man turned him in to the police. My uncle was subsequently arrested.

It was a harrowing affair of trumped-up espionage charges, interrogations while blindfolded, and weeks in solitary confinement—an affair that haunts my family to this day. My uncle was arrested on charges that he spied both for the CIA and the Israeli secret police. It took months and months to clear his name, during which time my mother helped collect evidence to prove his innocence. At one point, he even came close to being shot by a firing squad.

It's not hard to understand, then, why my family members in Iran were living on edge. Every morning, they awoke to hear the radio broadcasting the names of the prisoners who'd been shot by a firing squad the night before. The selection seemed so random, and they were terrified that one morning they would hear my uncle's name.

My uncle's wife and kids were also living in Los Angeles, and there was no one to visit him in Tehran. So every Wednesday, my mom would take a bus to Evin Prison, which was noted by both Iranians and the international community for its political prisoners' wing. My mom would wait in line for two hours, sometimes longer, just to have a five-minute visit with her brother. Oftentimes she would bring papers, which he stored in his jail cell and which eventually helped prove his case to the Islamic courts.

> " *Every morning, they awoke to hear the radio broadcasting the names*
> *of the prisoners who had been shot by a firing squad*
> *the night before. The selection seemed so random, and*
> *they were terrified that one morning they would hear my uncle's name.* "

We considered it nothing less than a miracle when we learned that, after twenty-two months, my uncle had been set free.

Shortly thereafter, my father was able to discreetly find a buyer for our beloved home. The house meant a great deal to my father. It was a testament to his success and wealth. On weekends he used to drive us in his cherry-colored BMW to one of the most fashionable neighborhoods in town to check on the construction of this dream home. We moved in when I was nine years old. Sadly, he had to sell his home at a fraction of its worth to a man who peddled birdseed in the bazaar. This new buyer was a religious man with an influential cousin in the *majles* (parliament). His plans for the house were heartbreaking. He intended to rip out the Western-style toilets in the bathroom near the entrance hall and build separate entrances for men and women. He also planned to erect a wall on the balcony to protect the women in his family from the roving eyes of strangers. Sad as my father was to say goodbye to the dreams that house represented, it was clear to him that those dreams were no longer within reach in Iran. He sold the house and left his remaining properties to be confiscated by the government. He had no choice.

Various portraits of the Ayatollah Khomeini found on the walls of Qom, the capital of Shi'ism, 1979.

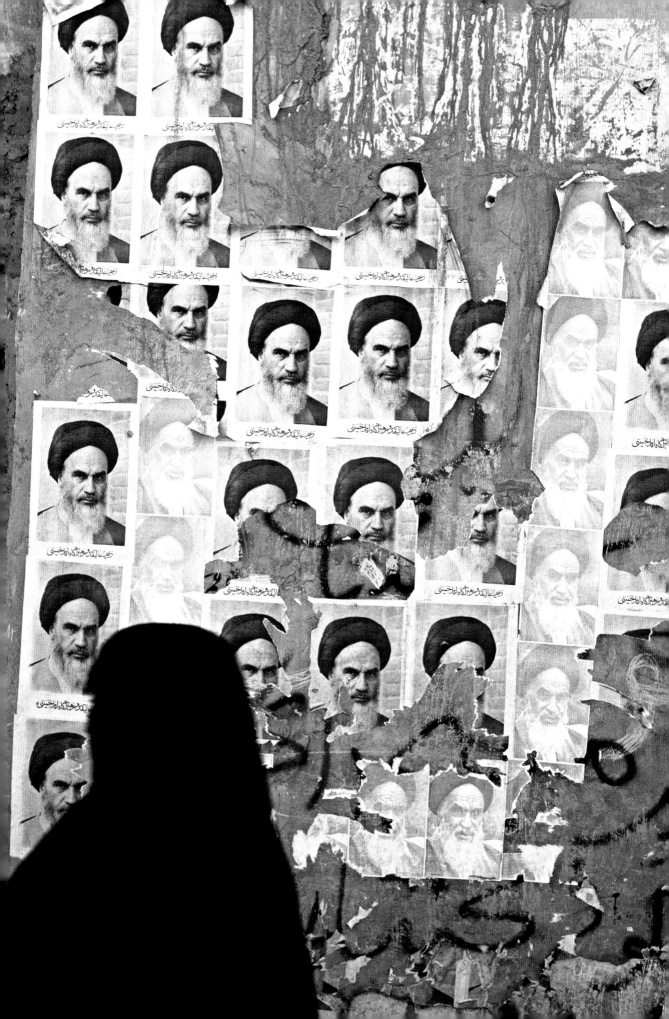

Ruins

I did not come to watch people
promenade through plazas and shops.
I came to see the ruins,
discarded places
set against the backdrop of
fleeting-cloud-filled skies
and bleeding sunsets.
In Rome
I walked through the **Colosseum**,
its crumbling walls framed by arches and windows.
I strolled through the arcade,
a witness
to gladiators fighting to their doom,
public executions and animal hunts.
But this place

had a gaunt beauty
fallen into neglect
that reminded me of what was left behind.
I thought of the beauty of the friend
who sat next to me in
my ancient civilizations class,
the one who stashed a wad of gum in her cheeks
while playing tennis,
the one who scribbled notes to me
telling me of her summer plans to visit Rome.
She was the one who took things
to the brink of too hard.
She went home one day and sat behind
her father's desk
put a gun in her mouth
blew herself away.
She too has **yielded** to the earth,
part soil already.

In **Machu Picchu**
I thought of the old man
I had seen while driving

through the Andes.

Fresh out of church and a drinking binge,

he stumbled in the road and

gashed his head on the pavement.

Blood streamed down his face.

"Dejame morir," he cried out,

"Let me die."

I drove on

and came to the ruins

where I walked in the mist.

My hands moved across

the well-worn surfaces, moist with dew.

Like the old man,

they were remnants of forgotten lives,

dreams buried with the dust,

of one thousand and one

entanglements.

How easy it is

to forget

that there is a world of **broken rivers**

beyond the tourist's gaze.

In Cambodia,

I walked through a maze

of fallen sandstone and lava rocks,

faces carved in devotion,

figures of Gods and beasts

in wondrous proportions.

Preah Khan was once

the willful vision of godliness,

filled with riches,

sumptuous silks, gold and pearls,

since raided

by tangled roots.

I heard the wind carrying

a melody that bloomed into numberless

waves of sound.

Next to the rubble,

on the overturned stones thick with mud

sat six musicians,

land-mine victims with severed limbs.

An occasional toe plucked a santur,

a lone thumb and finger played the flute,

stubs of legs pounded cymbals together.

Shapes without form,

casting their life as an offering,

beating out the rhythms of a wild, raging heart.

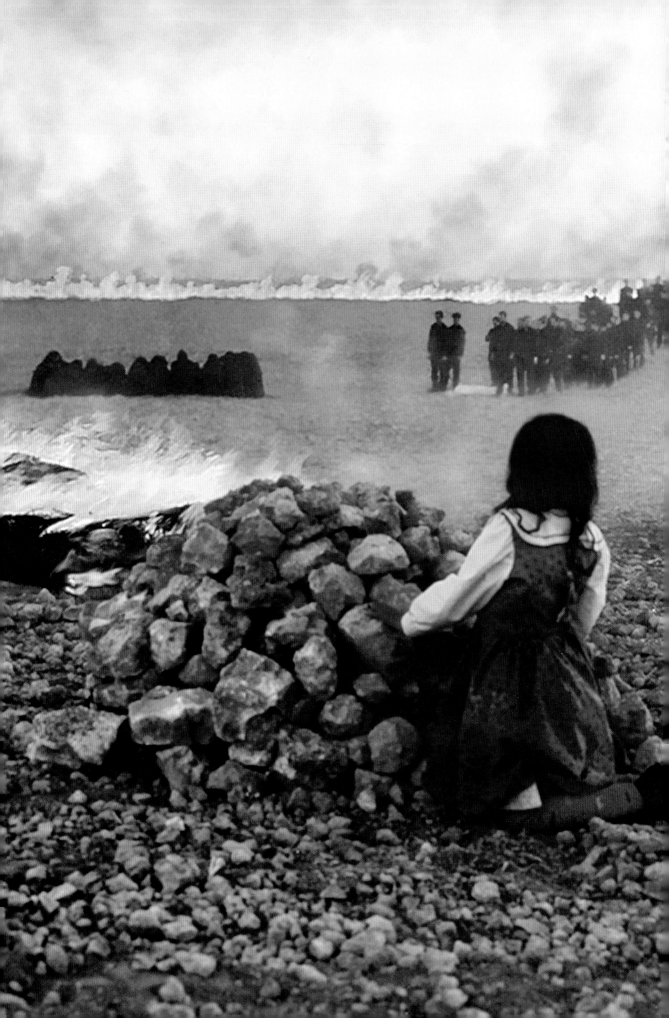

Death in the East, Sorrow in the West

 For years I used to think back to that last morning I spent in Iran, riding in the back of my father's car. The early-morning frost had melted away and I looked out the window, taking in each detail of the scenery as it reached my gaze: The fire already blazing in the *tanoor* of our local bakery, anti-shah graffiti spray-painted on walls in Pahlavi Street, a few torched-up stores along the way; the fog slowly rolling upward to the base of the Alborz Mountains. It was the crack of dawn, and the daily rhythms of the city had not yet started. I sat and watched miles and miles of empty road move endlessly toward me.

That morning in the car, I had no clue that I would never be able to travel on those familiar roads again. I didn't realize I would never set eyes on the jasmine and the lush pink primroses in our garden or pick ripe organic tomatoes from my grandma's garden. It was impossible for me to imagine that I would no longer smell the sweet scent of my aunt's orange blossom perfume, that I would never sleep over at my grandparents' house on weekends. No more Friday-night dinners with my cousins. No more pleadings with my uncle to have his kids stay longer at our house. No more domino marathons with my grandfather. Those experiences were unique and final, never to return.

The news that traveled from Iran to California was not good, to say the least. We got word that my widowed aunt had died of a stroke, leaving behind two children. We knew what that meant to my dad especially. He was consumed with worry over how these kids would

make it on their own and wanted to do what he could for them before he left Iran. There would almost certainly be no second chances.

More bad news followed. One night at three in the morning the phone rang with a call from my father. (It was never a good sign to get calls in the middle of the night.) In the morning I sought my sister out to get the news. She was in the kitchen, boiling water for tea. She was wearing a robe, hair in a ponytail, with a sober look on her face. I thought something had happened to Mom and Dad. I put my hand on Lida's arm. She was startled, not having seen me coming through the kitchen.

"You don't look so good, Lida. Is everything okay?"

The kettle started whistling and hot steam forced its way through the spout. "Can you give me the pot holder, please?"

I went over to the sink and got the new floral pot holders with red diamond quilting that we had just purchased on sale. As I handed her the pot holders, she said, "I got a call last night. We need to arrange for memorial services for Babakhosro."

That's the nickname Dariush had given our grandpa when he was young, and the name had stuck. I had fond memories of my jovial, potbellied grandpa, who always bragged, "I eat everything I want and I'm healthier than anyone around." He was a mild-mannered man who loved playing dominoes. I used to sleep over at my grandparents' house on weekends and we would have hour-long domino marathons while snacking on pistachios and dried mulberries. I was fascinated by the false teeth he used to put in a glass of water by his bed while he took his midday nap, and I used to walk behind him, giggling at the way he shuffled around the house.

"Babakhosro is dead? How did that happen?" I asked.

Lida let out a sigh. "Well, a few days ago, an ambulance driving down their street lost control and went onto the sidewalk and hit him, right near his house. He bled to death in the hospital."

"In the hospital?" I asked.

"You know, with all those land-mine and war victims in the hospitals, they weren't exactly looking out for an old man."

Tears coursed down my face. Of course, I also knew that this tragedy meant more delays for my parents. Now there were even more loose ends to tie up.

All this stress took its toll on my father. One evening my mother found him passed

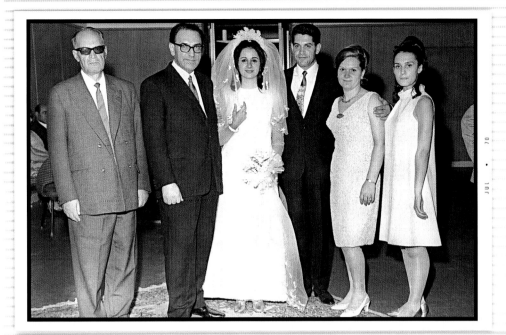

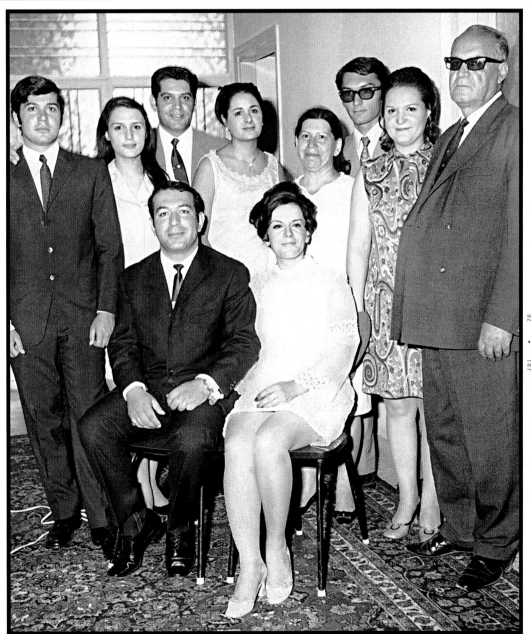

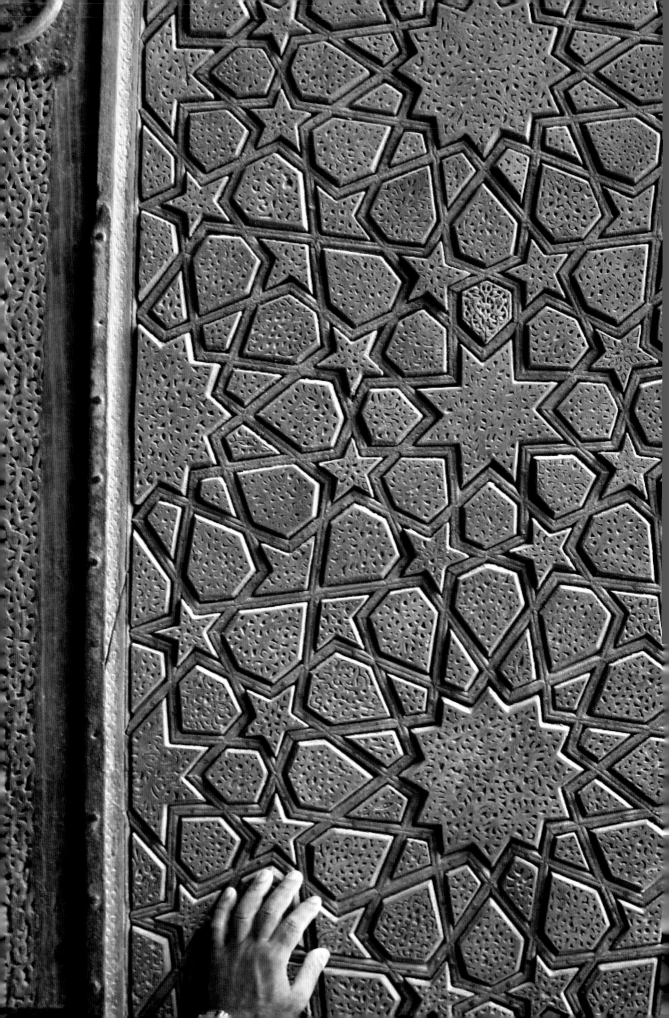

out on the kitchen floor. Because he was a heavy smoker and had a history of heart disease, the first thing that came to mind was that he had had another heart attack. But tests later showed he was suffering from internal bleeding. There just seemed to be an avalanche of sadness. We were told that my cousins were also not doing well, and later, word came that another uncle had died of a heart attack.

With all this sad news coming my way, I continued to cope with the distinct split between my past life and my rather comfortable new one. The word "death" was a vague and remote concept to me that I could hardly relate to in a meaningful way. It was easy for me to deny the reality of loss. Over the years that I had been apart from my family members, I had neatly tucked them away from my immediate awareness. With time, their presence slowly withered away in my life. To me, they all seemed to be living in a parallel universe in Iran, where I imagined them going about their daily lives just as I left them, frozen in time. My memory of them stopped when I was eleven.

I still imagined my uncle Khosro as a forty-five-year-old engineer with big sideburns and thinning hair. It didn't matter that he had died years earlier. I still thought of him living out the rest of his life in another land, just far away from me. Similarly, I thought of my dear grandfather drinking his mandatory glasses of tea with two lumps of sugar every other hour, sitting outside his house, watching the cars go by. My auburn-haired aunt who died of a stroke was still there, walking around her house in floral-print dresses, smoking cigarettes, and worrying about her two kids, one of whom passed away while we were in the States. For me, her son—a tall, lanky, green-eyed beauty of a cousin, with his face full of youth—was still engrossed in his backgammon games and solving mathematical equations. All these relatives to whom I once was so close . . . their passing did not break through into my life 7,500 miles away. Once I came to the United States, it felt like they had dropped off into a parallel universe where I'd never see or talk with them again. There was no concrete reminder of their deaths; their absence did not penetrate my daily life. As the years went on, they were slowly dying in my life, anyway.

It was not until years later, when my father was back in the United States and living with us, that my ideas about death began to unravel. My father had been a stronger presence in my daily life than other family members in Iran. When he died, he left behind so many empty spaces, things we would no longer do together. It was then that I was forced to come to terms with the finality of death.

Lonesome George

It's amazing how an aging tortoise can add some perspective to your life. I met Lonesome George on a visit to the Galápagos Islands when the wildlife was at the height of mating season. On the island of Española, male blue-footed boobies were busy with their courtship dance, lifting their feet and their tails, whistling, and fluttering their wings. These birds, like the other animals there, had no fear of us. They didn't run for cover; they didn't fly away; they didn't know what it means to be hunted down by humans. The blue-footed boobies nested and laid their eggs on the ground, ignoring the people walking by them.

I watched the wheeling and courting of the red-throated frigate bird on the island of Genovesa, with its forest of mangroves housing red-footed boobies, Sally Lightfoot crabs, and the nesting frigate birds. Because it was mating season, the male birds forced air into the patch of red skin at their throats, inflating it into a sizable red balloon, and made drumming sounds to attract the females flying above them. The whole landscape was drunk with lack of inhibition, yearning, and birdsong.

On the island of James, sea lions gathered in colonies on the sand and rocks, one big male in a harem of women. And on the island of Fernandina, iguanas clung to one another, basking in the sun, warming on the lava rocks. But Lonesome George lived a different reality. He was unlike any other animal in the Galápagos. Rebecca, the naturalist who showed us around the island of Santa Cruz, pointed him out to me.

"There he is, the one off to the side," she said. Lonesome George was

corralled with other giant tortoises, but he lumbered around on the periphery, picking at the papaya left over from his feeding. "Everyone was surprised when Lonesome George was found in 1971 on the island of Pinta," Rebecca said, "because it was thought that the last three remaining tortoises were taken off the island in 1906. Lonesome George is the only surviving example of his species. DNA scans have been done all over the world, and there isn't a tortoise whose DNA matches George's."

Before he was found, Lonesome George had lived in isolation for decades, an orphan, foraging through the arid hills and valleys of Pinta, looking for another of his kind. Nobody knows what happened to his parents, but the island's tortoise population was depleted by seal hunters and whalers in the nineteenth century. Because tortoises can live up to a year without food or water, many were taken aboard ships and stacked on their backs, one on top of another, in storage rooms, where they served as a steady food supply for sailors.

> 66 *Before he was found, Lonesome George had lived in isolation for decades, an orphan, foraging through the arid hills and valleys of Pinta, looking for another of his kind.* 99

When George was discovered, he was taken to the island of Santa Cruz so he could live close to other tortoises. But having spent most of his life on his own, George didn't know any other way to be. When other tortoises came around to pick over his food, George closed his eyes and drew his telescopic neck and small head into his shell. He retreated into himself until the others moved away and, after some time, slowly, cautiously poked his head out to become a spectator once again.

His singularity had posed a problem. Every measure had been taken to encourage George to mate with the female tortoises. At first he showed mild interest in some of the females, but his clumsy encounters confirmed his incompatibility. In the end, George had to give up what he never had. For him, there has never been an embrace, no courtship dances, no display of tenderness, only a stunted primordial urge to come together. When I saw him, Lonesome George was well into his eighties. And when he dies, the two million years of evolution locked away in him will also disappear. He will join the other extinct races, erased from this earth. Gone, without leaving a trace of himself.

I looked out from my bench at the coastline, where I could just barely see specks of the nearby islands. Some of them were volcanic wastelands, charred black, while others

Preceding: Monumental stone griffin at the entrance to the palace in Persepolis. In Persian lore, griffins, or *homa*, guard buried treasure. *Opposite:* From Rumi: "The power of love came / and I became everlasting power."

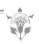

were lush and inviting. Each had a distinct character, with its own unique species that had evolved in isolation for millions of years. Each was a world within itself, straddling the equator . . . near its neighboring islands, but ultimately isolated.

Back at home, I drive by this woman in her fifties who sits on a bus bench in front of the UCLA medical center with a backpack by her side. She talks to no one and bows her head as people walk by. Her loneliness draws her down like a stone, pulling her deeper into her own world. And there is the man who wears expensive business suits and stops by Starbucks for a shot of espresso every day. His expression is serious and remote, and he usually mumbles to himself as he takes his seat by the window. He seems sealed off and unavailable, as if half of him is busy with a dialogue taking place inside his head. It has been me, too. I remember when my parents made that emergency phone call from Pakistan. I recall bits and pieces of the conversation: "We were robbed," "We have no money," "The police can catch us and send us back to Iran," "We need help . . . fast." Before the frightening largeness of life and its unpredictability, the only thing I wished to do was to retreat into myself.

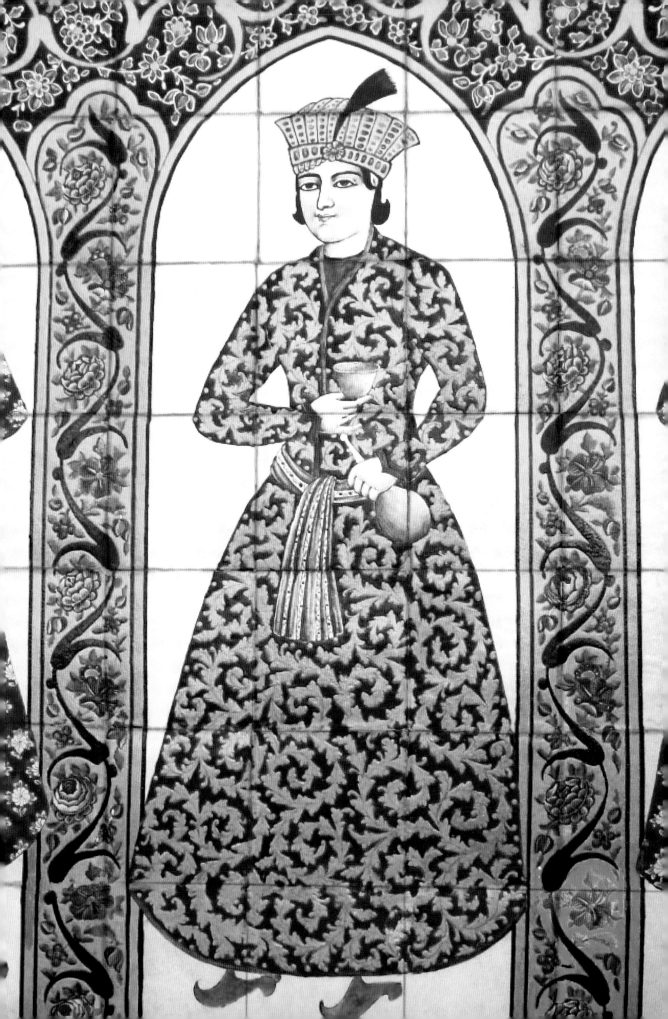

"We're Finally Here"

What I told my kids while waiting for the African wildebeests crossing by the Mara River—that you have to have patience, and a little faith—was something I kept telling myself on a daily basis during those years that my parents were away. Sometimes things don't turn out as expected, but I needed to remind myself to have patience for things to be resolved.

My parents had called from Israel and told us the good news—they were coming to LAX on the sixth of January, at six in the evening, on an El Al flight. That afternoon, the whole family came home early to get ready to go to the airport. I was worried about how my parents would see me now as a sixteen-year-old. I spent the afternoon choosing my clothes, settling on a fuchsia-colored pair of jeans with a striped shirt and a black blazer. I wore my favorite shoes, which I saved for special occasions. I had been looking forward to this day for so long, but I felt more anxious than happy.

While I was getting ready, so many practical questions popped into my head. From now on, who would give me permission to go out with my friends? Should I ask my mom? Or should I ask my sister? How would the new sleeping arrangements work in our house? How long would it take for my parents to get to know me as a semi-American teenager? How would my parents adjust to this new, hustle-and-bustle kind of life in California? All these things—some mundane, others critical—raced through my mind.

Everyone else was buzzing with nervous excitement, too. I went

to the kitchen and saw that Lida had prepared a feast: two different stews and various types of traditional Persian rice. The table was already set and the smell of chopped herbs and steamed rice permeated the house. It was odd to think back to the last time that my parents and their five children had sat around a dinner table. It must have been when I was four years old. Soon we all gathered in the kitchen to organize our caravan to the airport; Dariush and I went in one car, Jamshid and his new wife and Kourosh went in another, and Lida and her family followed in a third.

> 66 *It was odd to think back to the last time that my parents and their five children had sat around a dinner table. It must have been when I was four years old.* 99

I always enjoyed riding with Dariush. Our common love for music made for some lengthy debates as we compared notes on our favorite kinds. For me it was the punk-rock and New Wave artists, like Adam Ant and A Flock of Seagulls, that came from Britain. For him, it was more hip or classical Italian and French artists. That day in the car, Dariush put on one of his newer music compilations and we both sank into our own worlds. We barely said a word to each other.

While sitting in the front seat, I replayed my last conversation with my mom in my head. She had called from Israel a week ago, and for the first time, our talk was not short and telegraphic like all the others over the last few years. There was a comforting sense of ease in her voice.

"Angella *jaan*. I miss you so much," she said. "Your father and I are doing much better now. We even spent a few days here in Israel visiting relatives. And guess what? In Tel Aviv I found this beautiful jewelry box made with inlaid mother-of-pearl. Right away I thought of you. I hope you'll like it."

Of course, I was polite and thanked her for thinking of me. But there were more pressing feelings I censored out of our conversation. I wanted her to know that she didn't need to protect me from all that had occurred. There was no use pretending her five-and-a-half-year absence was simply a happy go lucky vacation. During my childhood, souvenirs from my parents' travels had been a great consolation for their being away: new clothes, shoes, gummy bears, German chocolates. But I was no longer a child, and they

Preceding: Tiled interior wall recess of the biruni in Naranjestan, Shiraz.

were not on vacation, either. I didn't want a bittersweet memento from their fugitive trip. I did not want us to act like nothing had changed.

Our decision to immigrate to the States was a risk and a complete act of faith—faith that in this new land a better life with more opportunities awaited us. We made the leap, hoping that we would thrive once again. We all took a chance. Things may not have turned out exactly the way we had envisioned. But there was no need for my mother to make it up to me. What really mattered was that I could be with them again.

By the time Dariush and I got to baggage claim, my siblings were already huddled around my parents. We had to navigate a maze of people and luggage to get to them. I called out their names, but the announcements over the loudspeaker drowned out my voice. My mom had her back to me as she hugged Lida, who was wiping tears away. I approached her, and as soon as her eyes met mine, she turned to me and called out my name, "Angel *jaan.*" There was a rush of conflicting emotions when I turned to hug my mother. As we smiled at each other's welcome, a sense of relief tinged with sadness, frustration, longing—sheer joy with an ever-present sense of grief—welled up in me. I rested my head on my mother's shoulder and sobbed while my mom stroked my hair. She whispered through her tears, "Can you believe it? We're finally here."

As I wiped my tears off my face with the backs of my hands, I ran to my father. He greeted me with a weary smile. The moment I wrapped my arms around him, I was overwhelmed by feelings of loss. I had missed him and was stunned at how much he had aged. He now had a head full of gray hair. The father I knew, the man of power, had been left behind in Iran, and the man standing in front of me now was an older man with familiar blue eyes and wrinkles bearing new secrets.

Seekers of Love and Faith

The first day I met her,
my friend sat with her eyes closed,
head tilted back,
sun warming her face,
and a cigarette in hand.

Thick curls draped
the back of her chair.
I sat two tables away
on the patio of the college cafeteria,
wondering who was

behind those closed eyes.
Twenty years later,
I wait to see her again
on the patio of the American Colony Hotel

in **Jerusalem,**

minutes away from the **Wailing Wall.**
Isn't it ironic, a pair of Angelenos,
meeting halfway across the world
near the most sacred site in Jewish tradition?
Where it's said God created the universe.
Where Isaac was bound by Abraham.
Where Jacob slept and dreamt of a ladder going up to heaven.

Where the Divine is **ever present.**

The **truth** is,
when I look at the people gathered here,
each generation enacting the identical ritual
over thousands of years,
heads pressed against the wall
in surrender,
in search of intimacy
with love and faith,
that's sacred enough for me.

Tiny papers
inscribed with prayers and wishes
are folded and stuffed in the crevices of the wall.
Don't **we all want** to rewrite
parts of our lives?

Making my way from the Wailing Wall,
to the Colony Hotel

I thought about my dear friend.
Glad that she never became

a **brittle beauty** of the suburbs.

They say she is terminally ill.
I say, who isn't?
She was coming straight from
months-long treatments
to see me.

When I saw her last,
she stood **exposed,**
wisps of hair peered out
from under her
self-constructed turban.
Her hair,
brown feathery tamarisk flowers.
She doesn't realize that
when the flowers fell
the fruit appeared—
her essence came through.
Twenty years of knowing her,
but I only know her now.

The truth is,
cancer is not contagious,
but crying is.

We both cry
as my friend and I lock in an embrace
on the patio of the Colony Hotel,
enacting the ritual of the Wailing Wall—
heart meeting heart,
our griefs and joys,
love and faith
rushing toward collision.
She and I, old-time friends,
reveling in the mystery of meeting each other anew.

A **melding** of our history.
Ever grateful
that together again
we'll see life's harvest of the coming year.

Legacy

It was the third of July.
We sat outside on the terrace and watched the fireworks in the distance,
marking an early celebration of some sort of independence.

We glanced over at my father,
dressed in the tux he wore to his son's wedding, an orchid in his lapel.
As always, he was formal, sitting with perfect posture, a grin on his face.
That's how he was, my old man with the silver tufts of hair,
in the photograph I had enlarged and framed

to put in the wreath
we brought home after his memorial service.
On the family cruise we finally made to Alaska the following month
to celebrate what would have been my parents' fiftieth wedding anniversary,
the dear old man with the silver hair was forever gone.

Things not done,

steps not taken,

leave something behind.

I sat for hours on the deck,
watching the icy ridges of the glaciers infused
with the crystal blue of my father's eyes.
They soared into the Juneau sky.

Mounds of ice snapped off the glaciers,

crashing into the ocean with a thunderous blast,
explosions that never stirred the stillness below the surface.

These rivers of ice are master carvers,
excavating bedrock, leaving behind fields and valleys,
refashioning a landscape in retreat from such cold embrace.

I sat for hours on the deck,

thinking of the last few months of my father's life.

Words unsaid carve out their own landscape.

On a day excursion on shore,
I saw the salmon in nearby rivers
lash against currents to spawn in the waters where they hatched.
Exhausted, they flailed about,
rubbing against the gravel and rocks in the shallow river, bloody.
They die soon after they lay their eggs,
there's nothing more to give.
They laid in waste by the riverbanks,
their lifeless bodies washed downstream.
All this effort to leave something of yourself behind.
Sitting on the deck
took no effort

I did nothing,

I said nothing,

hands empty,
leaving everything I knew behind,
only to sort out what was being offered

in the absence of things.

Empty Spaces

 I was sitting next to him, holding his wrinkled hands, when my father passed away. I was reciting prayers at the time his fingers twitched in mine, his body shifted to one side, and his eyes opened without expression. Although he was heavily sedated, it still looked painful. And my heart wrenched.

My father was known to be a distant man, cerebral and logical. But I have never felt more lonely than the moment he died.

Five months later, as I was getting dressed to celebrate my thirty-fourth birthday, I noticed a bump beneath my rib cage. I didn't think much of it until I went to bed and began to wonder if this bump was life-threatening in any way. Thoughts of my father and his passing came to my mind. He had left so many empty spaces. His favorite chair remained empty at the dinner table. His shoes still lay in the closet. No one would shuffle into the kitchen to greet me and play a round of backgammon when I came for a visit. A black cloud seemed to have been following me for the past few weeks. As I lay under the covers, I lifted the top of my paisley pajamas and felt the bump on the left side of my abdomen. Yes, it was there. It wasn't my imagination.

I don't know exactly when I began to panic; perhaps a week had elapsed, but that storm cloud hovering over me unleashed its rain. I was driving in the car, having dropped my kids off at school, and cried all the way back home. I am usually not one to think morbid thoughts, but that day I did. I was a mess, terrorized by the images that were flooding my mind. I imagined myself lying there sick, under hospice

care. I feared that my younger son, Eli, would not remember my face a few years after I was gone. My older son, Phillip, would graduate from college without me capturing his proud smile on home video. I felt inconsequential, knowing that one day I too would leave empty space in places I had once occupied.

Having been at my father's side for his passing, I understood that death is a solitary experience, and no one can come along on the journey. Maybe someone would hold my hands, but at the end I would leave that behind, too.

The Jewish ritual of Yom Kippur took place in October that year, right before my birthday. Just three weeks before we had all recited a passage in unison at the temple:

> *On New Year's Day the decree is inscribed and on the Day of Atonement it is sealed; how many shall pass away and how many shall be born; who shall live and who shall die; who shall perish by fire and who by water, who by hunger and who by thirst . . . who by earthquake and who by plague. . . . Man's origin is dust and he returns to dust. He is like a fragile potsherd, as the grass that withers, as the flower that fades, as a fleeting shadow, as a passing cloud, as the wind that blows, as the floating dust, yea, and as a dream that vanishes.*

I suddenly recalled this passage and thought, where was I inscribed in the Book of Life? What is written in my decree? Will I leave behind those I love in a year, a decade, fifty years, or tomorrow?

I thought I was comforting young Eli at the time of my father's death by telling him about reincarnation—how people are reborn, how they come back on this earth and live again. To be honest, I wasn't even sure how I felt about it, but I wanted to offer it as a comfort to him. A few weeks later, I picked him up from school and noticed that he was unusually quiet. I took a peek at him through the rearview mirror. He was lost in distant lands, looking out the window. I kept looking at him, trying to decipher his thoughts. Eli does not have extraordinary features: medium-sized brown eyes, a sloping round nose, fleshy lips, and a square chin. But when you look at him altogether, not at his individual features, he is a masterpiece. I kept looking at his hand—dimpled and youthful. Sometimes my heart flutters when I think how pure and innocent he is.

"Eli, what's the matter, honey?" I finally asked.

Preceding: Acacia tree in Kruger National Park, South Africa. The speck of tree in the vast barren landscape is reflective of my emotional landscape at the time I took this picture, not long after the death of my father.

He burst into tears. "I don't know. I don't know what life's about."

"What do you mean?"

"Why do people live? Why do they come here and then die?"

His face was flushed, and tears welled in his eyes. "When people die, they come back again? What's that for?" He put his head down and cried.

I pulled the car over to the curb, got out of the car and into the backseat and sat next to him, holding his dimpled hands. I leaned over and kissed him on the top of his head. "Eli, my love, maybe it is because we want to help others. Or maybe because we want to come back and be with those we love and enjoy life."

In truth, I had been asking those exact same questions.

It took many weeks and several mistakes to figure out that the lump in my abdomen was simply a fatty deposit. But by then I had already realized that my anxiety over my health had come from a different source.

That following summer, we went to Kruger National Park in South Africa for our first safari. My father used to ask, "Why would anyone schlep all the way there when you can see all the animals on TV?"

We were awakened at 5:00 a.m. and were ready to leave the camp by 5:15. Out on the game drive, we spotted a female leopard, one of the most elegant of the plains predators, that had dragged a dead kudu, a kind of antelope, up onto a tree branch. The tracker was beaming with excitement. It isn't every day that you see leopards; decades of poaching have diminished their numbers. This one paid no attention to us. She lounged on a tree branch near her prey, her body supported by the branch, limbs dangling down. There it was—life and death suspended on the branches of an old acacia tree. Death had ravaged life and left it hanging there, to consume it and gain nourishment once more.

> **66** *There it was—life and death suspended on the branches of an old acacia tree. Death had ravaged life and left it hanging there, to consume it and gain nourishment once more.* **99**

By 5:00 in the afternoon, as the light grew golden, we began to descend into a grassy stretch of land with heat waves shimmering in the distance. It's a haunting landscape, hardly different from that seen by humankind's ancestors millions of years ago. We saw two elephants eating grass in a wooded area, and just three hundred yards over, we spotted another kill: A buffalo was brought down by a pride of lions. The air was thick with the stench of the slaughter. It was a violent landscape of blood red, grays, and browns. The carcass was partly

picked over by the pride, and the lionesses were busy nursing their cubs. There it was again—the inevitable and seamless flow of life and death. We fell silent. We watched the cubs fight one another to be nursed; we saw two more lions sitting by the buffalo, ripping the flesh off the buffalo's hind legs. I wondered, had this buffalo sensed danger before it met its end? Did the lions ambush and run toward the buffalo with terrifying speed, or was it a slow stalking?

We watched the lions for a long time, dazzled by the splendor and vastness of nature. "What a masterpiece," I marveled. The sun was fading, and we had to head back to our camp. As the driver turned on the ignition, I closed my eyes and felt a warm breeze brush against my face. For a few seconds I felt that my father had returned and was filling the empty spaces.

These intricately decorated concave hollows hang down in clusters, and are thus nicknamed stalactites or honeycombs. This type of decorative art is seen in many old mosques and buildings throughout Isfahan and Shiraz.

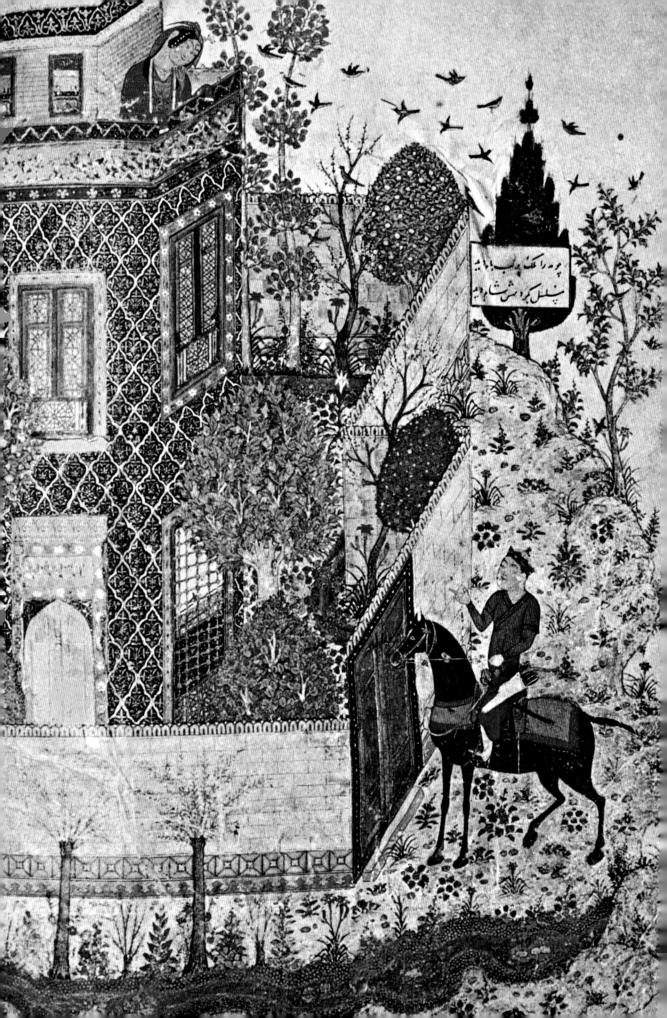

David

Los Angeles is the second-largest city in America. And when I arrived as a child, I basically didn't know anyone except my immediate family. So it might be surprising to learn that I met my future husband, David—and his whole family—at the ripe old age of thirteen. To me it makes complete sense.

No, I don't mean that there was any kind of Old World matchmaking going on. When I was thirteen, I was more interested in playing basketball than finding a boyfriend. But like the millions of hyphenated Americans who make up the melting pot, first-generation Iranian Americans have formed a close-knit community. Many of us live in the same neighborhoods, send our kids to the same schools, and do business with one another. And if that's not enough, we all seem to be related in some peculiar way (someone's great-uncle is always another's second cousin twice removed). Forever in the spin cycle, we inevitably bump into one another at parties and family get-togethers.

Indeed, I met David and his family at Jamshid's engagement party. I didn't know him then, but I recognized his sister, Sharon, immediately. Back in Tehran, during those few months that I attended Etefag, she had sat two rows in front of me in my science and composition classes. Later, when we were both at Beverly Hills High School, I ran into her in the hallway and introduced myself. That encounter with Sharon in ninth grade led to a lifelong friendship.

I always thought of David only as Sharon's older brother. Whenever I saw him at parties, I naturally asked about Sharon. But it was at a

friend's summer party, right before the start of my junior year at UCLA, that David and I really got a chance to talk. That evening we chatted about everything from his recent trip to Tahiti to my job as a research assistant in the UCLA psychology department. Once I got home, I thought the six-year age difference between him and me didn't seem so bad. And, to be honest, his good looks didn't hurt. A couple of weeks after that party, David and I started dating. Four months later, we were engaged.

This whirlwind romance left my non-Iranian friends' jaws hanging open. For them, this was impulsive. Most of my friends didn't get married until they were well into their thirties, only after having dated their boyfriends for a few years. But in Iranian culture, girls don't date. You only go out with a guy if you think it's going to be serious. Don't ask me what I knew as a nineteen-year-old that led me to make such a life-changing decision. But, after only four months of dating, David and I knew it was the right thing to do. Now, after our bond of some twenty years, I can reflect back on our relationship and see what it has offered me—mutual love and a deep sense of intimacy.

It is one thing to have family members love you—they have to. But it is quite another to have someone unrelated to you find you so interesting that he wants to spend the rest of his life with you. For me, it was the first time I entered a long-term relationship with my guard down (at least most of the time). And, perhaps paradoxically, marriage has been one of the most concentrated and intense ways of finding myself. Really, there is no way to fool anyone and pretend to be someone other than yourself during a relationship that spans two decades. It's been twenty years of *really* facing each other, on a field where our passions, differences, pleasures, difficulties, and needs constantly engage, to achieve a necessary balance.

I've realized that we discover who we are in our relationships with people. But no matter how similar we are in our values, my husband and I are still different people. Whereas David strategizes and is a long-term planner, I am engrossed in the immediate. He sees things in the framework of the larger picture, and I see the details and the subtlety of things. He is rational, and I, more intuitive. He is punctual and structured while I wander here and there, and let's say my concept of time and date is more abstract and flexible. He is more introverted and quiet, whereas I bound around the house and can talk to friends and family for what he perceives as endless amounts of time. But rather than serving purely as a source of nagging and frustration, these differences have forced me to face my own narrow vision— that there is no single way of tackling a problem or approaching life. And it is precisely this

Preceding: Humay at the gates of the castle of Humayun, from the Khamsa of Khwaju Kirmani, dated 1396.
Opposite, from top: A picture of the gardens in Alhambra, taken by my friend Tom O'Briant, and pictures of my honeymoon with David.

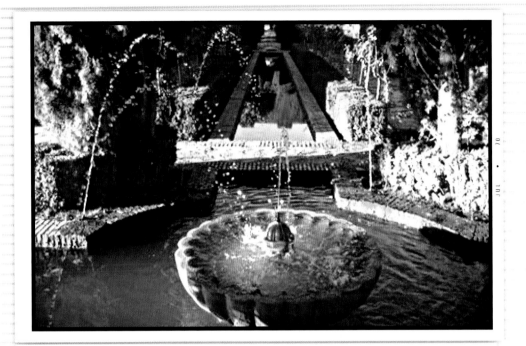

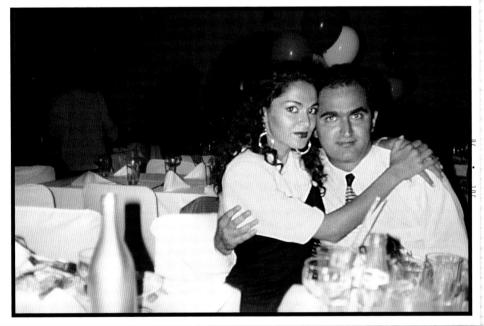

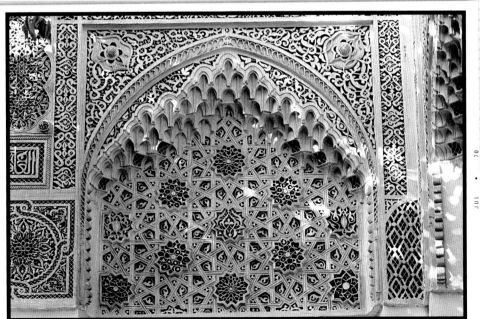

this dialectic that has made us grow and stretch our boundaries and, along the way, find deep joy and a rare, intelligent friendship with each other. After all this time, we still prefer each other's company. That says a lot about our relationship, but I can't take much credit. I was lucky to end up with a great partner and equally lucky that we have grown in the same direction rather than apart.

The fact that we got married so young has worked to our advantage. We were both open to change and shared a common vision of building a life together. It's no surprise, then, that world travel has become one of our family's passions. When it came to picking a destination for our honeymoon, the choice was obvious. I wanted to visit Spain. Maybe it was my sheer fascination with Latin culture—I was the only Iranian student in my class who chose to study Spanish, rather than the traditional French. I continued taking Spanish in college and studied the works of Lorca, García Márquez, Allende, and Vargas Llosa. As for the music, I can't get enough of reggaeton and salsa. But I think my choice of destination had something to do with the lure of living out my first childhood memory—sitting in my parents' living room, captivated by the poise and beauty of the Spanish flamenco dancer in our vitrine. One can only imagine why this trip to Spain was important on so many levels: It not only intersected with my childhood fantasy but also marked the beginning of my marriage, where I would also see the world through someone else's eyes. After all, marriage means not only passing over physical borders, but crossing over invisible and emotional boundaries as well.

Marbella, the most famous beachside resort in Spain's Costa del Sol, is a place that David, an avid traveler, had raved about, so it naturally became one of our honeymoon destinations. It was also a good place to relax by the beach and recuperate from our big, fat, weeklong, Iranian-style, shoot-me-in-the-head-hectic wedding in L.A.

In addition to Marbella, we also enjoyed exploring the rest of the region, including the historic city of Granada. The name Granada means "great castle" and refers to the Roman fortress that once stood on the Albaicín hill. When the Moors settled there, the town was largely inhabited by Jews and was aptly named Garnat Al Yahud—Granada of the Jews. To this day many doorways in the streets of Granada are adorned with inward-slanting mezuzahs, a reminder of the homes' past occupants. As we navigated our way through the maze of cobblestoned streets, I speculated about the wanderings of my own ancestors, who, I had been told, had moved through the southern part of Spain and the Iberian Peninsula during the Spanish Inquisition.

When we visited the magnificent palace of Alhambra, which stands at the foot of Spain's highest mountain range, I was struck by the Moorish and Islamic influence on Spanish

architecture and culture. Alhambra's gardens were typical of the great Persian "paradise gardens," with water cascading through them in shallow pools and countless fragrant fruit trees. This sprawling palace was also graced with Moorish arches, a mosque, a harem, tiled bathhouses, and walls decorated with elegant arabesques and Islamic calligraphy.

Every day I found myself in a constant state of wonder. This trip was the first time I had been out of the States since I was eleven. And I could feel that a whole new world was opening before my eyes. As we made our way through different parts of the coast, it became clear to me that Spain was caught in the crosscurrents between the East and the West, the melding and the eternally unstable union of two divergent philosophies. I was struck by how a place like Alhambra represented the union of heritages, Moorish arches and European flourishes. I knew then that I too would have to find my own way, navigate neatly between the two sides, carve out an identity for myself that was neither Eastern nor Western, but both at once.

Every day at dusk, David and I returned to our hotel, the Marbella Club, paused over glasses of sangria in the garden restaurant, and watched the staff go through the garden, lighting the hundreds of candles that had been mounted on the lower branches of the trees encircling the restaurant. It was a beautiful sight; each branch appeared to wear a white shawl of wax drippings that had accumulated from nights before. Here was a modern hotel, replete with all the luxuries one could wish for, but its charm came from the gracious ways it held on to the traditions of the old. Later we would make our way toward the hotel's terrace by the beach to watch the sun slowly melt below the horizon.

By nightfall, we would wander over to one of the outdoor restaurants by Puerto Banús, the famous harbor, with its constellation of yachts and boutiques. We had our dinners at around eleven and watched children frolic at the water's edge and lovers stroll through the winding pedestrian alleyways. But the best part of the day was after dinner, well after midnight: Those moments when we, too, strolled hand in hand by the beach, enveloped by darkness, hearing the sound of distant music and the lapping of the waves, smelling the sweet scent of jasmine in the air, not saying a word.

On our last night, as we walked back to our hotel, the night sky, immense and full of brightly shining stars, spoke to long-dormant parts of me. That night I knew that something important was happening to me. There was an intertwining of subtle emotions and memories. I felt an overwhelming sense of wonder at this vast planet that we had begun to explore. The rawness of firsthand experience was electrifying, a feeling I still connect to whenever I travel to a new part of the world, from Morocco to Mozambique. In a deeper way, though, I felt a great sense of freedom and coming of age. I was no longer held at arm's length, staring at the flamenco dancer in the glass case. Life was there and I was in it—experiencing it all.

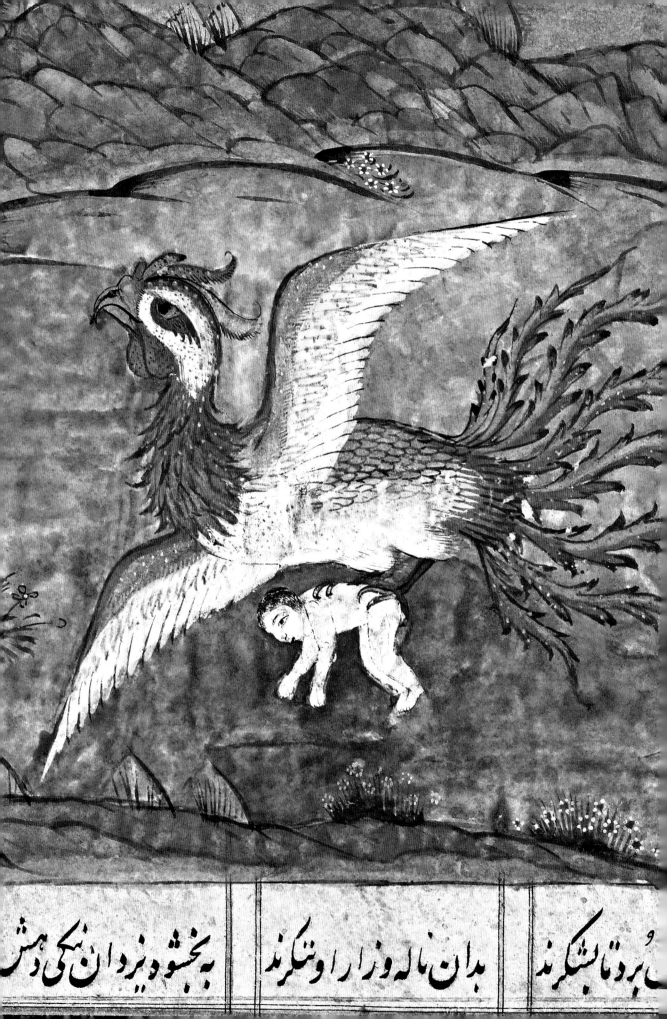

My Own Shining Stars

For most women, myself included, motherhood is one of the most important and transformative experiences in life. It is a dual union. You can become deeply connected to your child while at the same time reliving aspects of your own youth. For me, raising my children—and experiencing life as a mother—has helped add focus to my journey of self-discovery.

During my first pregnancy, I imagined a "natural," Zen-style childbirth. I pictured myself breathing in and out, controlling pain, and refusing those unnatural drugs, just like I learned in Lamaze class. Alas, what I envisioned and what transpired hardly intersected in reality.

First I passed my due date, and my labor was finally induced by a slow intravenous drip of Pitocin. Then came the twenty-two hours of excruciating pain, during which I had two epidurals to save me from the agony of contractions. Needless to say, all my holistic childbirth fantasies flew out the window when I hit that tenth hour. But, overachiever that I am, I started feeling like a miserable failure at childbirth. In this hysteria, I half-hoped that Dr. Allen, my obstetrician, was going to send me to the principal's office and have me redo this whole ordeal for a better grade. I was ready to dart out the door and get a rain check on this whole delivery process.

Doctors worried that the baby was in stress and had strapped my belly with a monitor to keep track of his heartbeat. I remember the circumstances of Phillip's birth clearly. It was July 30, 1992, near midnight. The recap of the Summer Olympics diving competition was

playing on TV. In the ten-meter platform dive, each competitor paused for a moment of concentration before leaping into the air. The divers turned and twisted their bodies with ease and grace as they plunged toward the water below. David and I sat watching the diving competition for hours while the delivery room reverberated with the steady, rhythmic heartbeat of our baby. We listened to Phillip's pitter-patter heartbeat for another four hours before he was ready to be pushed out.

It was in those last four hours of labor that a strange feeling washed over me. They say newborns are soothed by the heartbeat of the mother, but in my case I felt like both the newborn and the mother. As I listened to Phillip's heart beat, it dawned on me: For the first time I could grasp what my experience as a fetus might have been, being contained within my own mother, listening to her heart beat night after night. It was into this very primal and essential relationship that I, too, was born.

When Phillip finally made his debut and was handed to me, the first thing I did was place my pinkie in the palm of his hand. He reflexively wrapped his perfect and tiny fingers around mine. With that first grasp, I was pulled straight into his heart.

> 66 *While listening to Phillip's heartbeat, it dawned on me:*
> *For the first time I could grasp what my experience as a fetus*
> *might have been, being contained within my own mother,*
> *listening to her heart beat night after night.* 99

I noticed the changes in myself as I entered into a great love relationship with Phillip and later with Eli. Before Phillip's arrival, my days had revolved around my life with David. Now, during the day, while David was at work, Phillip and I became a pair. We enjoyed our daily outing to the park together and our walks around the neighborhood. I watched in delight as he took notice of things for the first time. As a new mother, though, I was worried about whether I was doing the right things, being a "good enough" mother. (Seriously, being a psychologist can sometimes make you more confused.)

When I started teaching social psychology part-time at the university, I would bring him along on campus with a babysitter. I was proud that all the students in my class knew his name and stopped to play with him. Of course, everyone seemed puzzled when they saw us together. Phillip and I looked nothing alike. He had green eyes, fair skin, and blond hair. I, with dark hair and olive skin, was often pegged as his babysitter. People even

Preceding: Illustrated manuscript, seventeenth century. Simurgh carries Zal to her nest, from the Shah Nameh, the tenth-century Persian epic of the kings. The Shah Nameh is the national epic of Iran and is regarded as a literary masterpiece.

stopped and spoke Spanish to me and sometimes inquired about my fees and availability, which always made me smile. I'm sure it was even stranger when both David and I were with him—David is even darker than I am.

With Eli's arrival three years later (an infinitely easier delivery), our family went through another transition. For months, we had prepared Phillip for having a little brother or sister. On my first day at the hospital with Eli, Phillip marched in and demanded to sit next to me in bed. He took a piece of bread from my breakfast tray and started munching. "Has he come out yet?" he asked, shedding crumbs from his mouth. I pointed at baby Eli in the clear plastic bassinet on the other side of the bed. Eli was red and puffy, curled up in a ball and wrapped tightly in a hospital blanket. Phillip looked disappointed.

"But when is he going to wake up so I can play ball with him?" That was his simple reaction. It took many months of guarding Eli from the overzealous, playful hands of Phillip, who at every turn wanted to sock him in the face with a basketball.

Since there was such a big age difference between my siblings and me, I always felt that I needed to catch up with them. Our day-to-day activities never really intersected, and we never even attended the same schools. But, with Phillip and Eli, I got to see firsthand how siblings who are closer in age interact. They went to the same school, played the same games, slept in each other's rooms, and talked about their teachers and school friends. Of course, Eli finally was able to play rounds and rounds of basketball with his older brother, which somehow ends even now in a big fight.

It was only when I became a mother that I could wholeheartedly empathize with how my mom felt all those years when she was stuck in Iran without her children. It took just one week of sleepaway camp for me to learn how hard it is to have my kids be away from me—and this was under the best of circumstances. My mom had to helplessly withstand the quiet slap of separation for five and a half years. Locked inside that nightmare, she was shut out of her children's great moments—Jamshid's wedding, the birth of his son, Kourosh's high-school graduation, and all our birthdays and celebrations.

> **❝** *It was only when I became a mother that I could wholeheartedly empathize with how my mom felt all those years when she was stuck in Iran without her children.* **❞**

She was unable to console us during some of our hardships, too, which must have caused her even greater pain. Our lives intersected only in those rare phone conversations. Thinking back, I realize neither we kids nor our parents ever mentioned that we missed each other. But those confessions would have only confirmed the infinite distance between us.

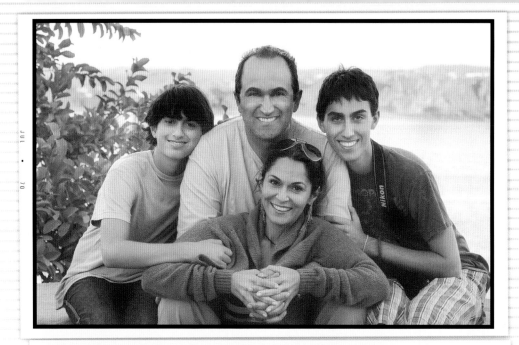

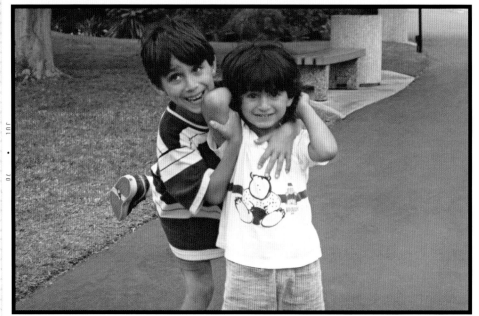

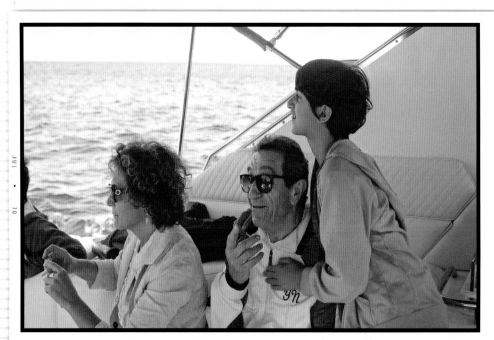

Each side wanted to be strong for the other. Now, with the broadened perspective of a mother, I can say that I hold the deepest affection for my mom's quiet force and all that she was able to do for us, even when her options were limited.

While watching Phillip and Eli grow, I have also found that I reflexively make comparisons between their childhood and mine. I remember that when I started school, for weeks I clung to my mom's arm and skirt, cried, and pleaded to be taken home while the stern teachers pulled me away from her. But neither Phillip nor Eli ever showed any signs of clinginess or separation anxiety when I took them to preschool. I spent days sitting with my reading material and coffee in the parents' room next to their class without either of them asking for me.

I started retracing an important part of my past when Phillip turned eleven, the same age I was when I immigrated to the States without my parents. That period of my life had been so marked by upheaval, crisis, and change that I had forgotten how young a child of that age really is. Phillip would come home in the afternoons and talk about his day at school, ask us about homework and how to deal with his friends. He looked to us for cheery support if he lost his basketball tournaments or had a bad day. While Lida was available for me here, I felt that my daily problems were dwarfed by the challenges that we were facing as a family. So most often I kept my concerns to myself. But Phillip, on the verge of becoming a teenager, still relied on us for the security and stability to try out new ways of behaving and being in the world. I now realize that a child of eleven is still dependent on his or her parents, which makes me wonder how vulnerable I must have felt in those early years without them.

Now that my kids are getting older, I see how they are slowly pulling away from me. Whereas they once felt like a natural extension of myself, I now see that they have become completely separate—and, dare I say, more fascinating—people in their own right. I am proud that Phillip is finding his place in the world, working at summer jobs, spending weekends with friends, and planning to go away to college. This is what David and I encourage in our kids—to go out and expand their horizons. But I also know that soon Phillip's world will be one where I am on the periphery.

When I talk of my anxiety about how the kids will soon be moving on and leaving me behind, some well-meaning friends suggest that I have another child. While I have enjoyed raising my kids, and know that motherhood has been a cornerstone of my identity and

Preceding, from top left: Family picture taken while visiting Egypt, 2008; Phillip, 5, playing with brother Eli, 2; Eli with grandparents Soraya and Younes in the Caribbean. *Right*: Phillip, 9, and Eli, 6, on a cruise in Alaska.

growth, I cannot imagine going through Mommy and Me programs all over again. I find it hard to go through the process of separation from my kids. This means that I, too, have to respond to their growth. There is a subtle difference between that feeling and wanting to continue the pattern of motherhood.

This constant negotiation between attachment and separation has marked my journey in life, especially as a mother. On bad days, I wonder if the process of separation from my kids is burdened by my own experiences of separation from my parents. But then, most of the time I know it is precisely this experience that has sensitized me so that I can really connect with my kids, to notice the little things they do, embrace their youth, and find joy in even the mundane aspects of their childhood.

* * *

Four years ago, David's parents, Phillip, Eli, and I spent a week on a boat in the Caribbean. One balmy moonless evening, when David and the boys and I were sitting on the deck, we decided to slip into the water. What I experienced that night, adrift in the warm waters of the sea, was surreal. The four of us were floating on our backs, submerged in the darkness next to one another, gazing at the starry vault above us. It felt as if we were cradled in the womb of the universe.

As we studied the galaxies up above, I spotted a shooting star flaring across the sky. I turned and said, "Boys, look to your left. Quick, make a wish."

Phillip was the first to call his out. "All right, I'll make a wish. I wish that Mom gets the same kind of massage she got in Cambodia. You know, when she smelled like Chinese food afterward."

His cracking, adolescent voice rang out from behind me. We all laughed. He was right. Back in Cambodia, when I came out of the massage room to join David and the boys, I could detect the sweet scent of peanut oil and lemongrass all over my body and hair. The kids teased me, saying I smelled like kung pao chicken. This is what kids do when they get older. Parents are no longer all-knowing, wise, do-no-wrong role models.

While floating in the water, the children remembered how I couldn't wash off the smell for days. I was laughing, too, but I was also feeling a twinge of loss while listening to Phillip's changing voice. My son was getting older.

Then Eli, floating next to me, spotted another shooting star. He started splashing around. "Look, guys. It's my turn now. Okay, I wish that Phillip gives me back the PSP game that he hid from me today." We all laughed again.

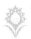

Over the course of half an hour, we made thirteen different wishes on thirteen different shooting stars—some for ourselves, some for our family and friends, and some for people we didn't even know. But I kept one wish to myself. I wished that as a mother I have somehow instilled in my kids a love for life—a feeling that it's okay to venture out and explore for themselves who they are.

When it was time to go back on the boat, David went up on the deck first and pulled me up. I got some towels out of a nearby basket while David helped the boys out of the water. Eli giggled and started stomping on the puddle of water at his feet. I wrapped a towel around him and felt his soft, slippery skin. I handed Phillip his towel, and both kids went inside to change. I wrapped myself in a towel and sat on the deck with David a little while longer.

Starry skies are called to be revisited
different paths need to be walked
new stories to be told
as new roles come to life.
The luminous stars
vanish in the daytime sun.

I am, still,
in the sun's reflection
at times crescent
and sometimes full.

Opposite: Poetry from Sa'adi, a celebrated thirteenth-century writer whose poetry graces the entrance to the Hall of Nations of the U.N. building in New York: "Unlike the sun that rises and sets / your presence is everlasting…"

Armored Barbarian

I

I carry a child, seven years old,
tucked deep inside my heart.
She gives me a hard time,
telling me I drive too fast,
that I talk on the phone too much
that my hairspray stinks.

We were once the same age, **this child and I.**
She taught me how
to float in the backyard pool,
spreading my arms out,
arching my back,
listening to my breath
with my ears in the water.
I taught her how to ride a bike
that had no seat or brakes.

Back in '79,
when we moved to the States,
she got uptight over
every little thing,
the broadcasts of President Reagan
calling us hostage-taking barbarians
and the slurs
scrawled on the sides of buildings
and bathroom stalls.
Once when I was riding my bike by the beach,
with Casey Kasem's American Top 40
blasting through the Walkman,
I came upon
these words spray-painted
on a parking lot wall:
"Barbarians go back home
but leave your daughters behind."
I caught my seven-year-old feeling relieved, thinking
that there was **hope:**
at least they liked the women.
But I only felt the slow spread
of a self-conscious **haze.**

II

I think of myself as a modern-day gypsy,
riding high in my SUV
*as a **refined barbarian.***
I gallop around in my armor
of Balenciaga, my shield of Prada,
with a dash of Chloé and Chanel.
My seven-year-old,
whom I've exiled for some time,
doesn't care about names and shields.
She sulks, knowing
that I'd rather be relieved
*of her impossible **needs.***

Friends leaf through my glossy travel albums
wondering why I've got so many
pictures of snot-faced children,
with peering dark eyes,
vulnerable and afraid,
staring back at them.
They don't know
that my seven-year-old is the one
looking through the lens,
wanting to capture
where she and I once walked.
I'm glad that she didn't give up on me.
We've resumed talks
once more,
inspired by the Middle East peace accords.

III

Just three years ago

we moved to Bel Air and became neighbors

with the Reagans.

It was the same day Ronald Reagan died.

The streets were blocked by police,

the Secret Service was there for a week.

The next morning

men in dark suits and earpieces,

constant vigilance plowed up their foreheads,

escorted me around the block

while I walked my dog.

They talked about protecting the neighbors,

the importance of **safety** and **security**

in this rarefied neck of the woods.

My seven-year-old whispered inside me,

"See, girls do get the longer end of the stick."

For that moment I had forgotten I was a barbarian.

Later that day

I nearly ran over Casey Kasem,

still in his bathrobe,

bending to get his morning paper.

My seven-year-old was **not amused.**

She told me I was driving too fast.

A couple of months ago

Nancy Reagan sat across from me

at a dinner party.

Wrinkle-free and ultrathin,

she must be a living American dream.

I, on the other hand,

doing yoga and acupuncture,

reading self-help books,

and talking to the seven-year-old
lodged in my heart,
must be the poster child for
California koo-koo.

I don't let on*, though,*
I wear my Prada and Balenciaga
with a dash of Chloé and Chanel.
I pick up the right fork
for the right course
and tilt my head
to laugh at men's jokes.
I talk about important stuff
like the war and politics
and global warming
and vacations on yachts.

Looking at Mrs. Reagan,
I smiled on the inside, thinking:
from riding bikes with no seat or brakes,
to reading graffiti on parking lot walls,
to breaking bread with the former first lady.
I tugged at the seven-year-old
deep in my heart,
and asked if she had anything to say.

"No," *she said,*
"I take the pictures,
I do the writing,
you look good doing the talking."

So, I talked about stem-cell research with Mrs. Nancy Reagan.

To Be Home

 It must have been the highlight of their day, maybe even their entire month: Here was a gorgeous, blue-eyed American blond stumbling into a Middle Eastern souvenir shop right by the border of Jordan and Israel, belly dancing in front of two middle-aged Arab shopkeepers.

My friend Cathi and I had walked into the store out of sheer boredom. We'd been waiting by the border for close to an hour to get our visas stamped. The only thing to do was to look at the tiny trinkets on display at the souvenir shop right by the guard station. But Cathi was intent on spicing up the morning. She took one look at the shop's video of a half-naked belly dancer doing her serpentine moves and decided to try those dance moves herself. Yes, right there. She stood in front of that TV, wearing her bubble ski jacket and baseball cap, gyrating her hips, moving her arms about, shimmying her shoulders for me and the two very grateful Arab men. Believe me, it was a sight to see. The men dropped their newspapers, first looking our way in paralyzed surprise. But it took no time for them to catch on.

"Yalla, yalla," they said as they clapped in encouragement. I was hiding between the aisles, laughing hysterically at my friend's uncoordinated attempts at 8:30 in the morning, with a belly-dancing scarf tied around her hips.

We were only a few minutes into Cathi's impromptu act when her husband rushed into the store. He did a double take. I don't blame him for being confused by this bizarre display—me squatting on the floor laughing and Cathi dancing—hopping, really—around the store with

cymbals in her hands. But John, like my husband, takes these Felliniesque moments with good humor. Time spent with us is like an afternoon with Lucy and Ethel.

"Okay, okay. Playtime is over. We can finally go through the border," John said. Cathi put the cymbals back on the shelf, laid the scarf on the counter, and bowed to the shopkeepers. She had obviously forgotten we were not in Japan. People in Jordan don't do geishalike bows. They simply say thank you. Nonetheless, in keeping with true Middle Eastern hospitality, the shopkeepers offered her the scarf as a gift. Lovely.

A short drive through the desert took us to the outskirts of our destination—the famed city of Petra, now one of the Seven Wonders of the World. I had seen pictures in travel magazines, but they did not prepare me for its grandeur.

It took us another forty-five minutes on foot, through long, twisting canyons called the Siq, to get to the interior of the historic city. The surrounding walls of the canyon, awash in waves of different shades of red, were so high that they shut out the morning light. Our guide, Salam, explained that during the centuries right before and after Christ, Petra was a thriving civilization and a trading empire. The very trail we were walking on once served as a major caravan route between Arabia and Syria. Roman soldiers on horseback and rich merchants with their camels trekked over these winding roads trading saffron, exotic oils, and incense. Today this narrow passageway also serves as Petra's main entry, like the eye of a needle, threading us through the dark cavern into the light. Without a doubt, it is simply the most spectacular and dramatic entrance to a city that I have ever seen. The treasury, an imposing classical building carved into the soft stone of the mountain some two thousand years ago, marks the beginning of the city. This magnificent sight peeked out from around the last bend of the Siq—behind those jagged, rose-colored cliffs.

As we walked through Petra into the more expansive spaces, Salam pointed to the visible black holes in the cliffs nearby. "These openings you see are entryways to the tombs that the Nabataeans carved out for their ancestors. Eight hundred have been spotted so far. The ones you see farther away with the Romanesque architecture may have been used for escaping the summer's heat."

We could tell that the Nabataeans drew from varied styles of architecture. An unusual mix of Greek columns, Roman-style amphitheaters, and Indian-inspired elephant-head carvings was incorporated in tribal and Mesopotamian dwellings. This eclectic group of building styles reflects the influence of the different cultures that once came through this part of

Preceding: View of the treasury in Petra.
Opposite: Unidentified artist, *Composite Camel with Attendant*, opaque watercolor on paper, c. 1570-80.

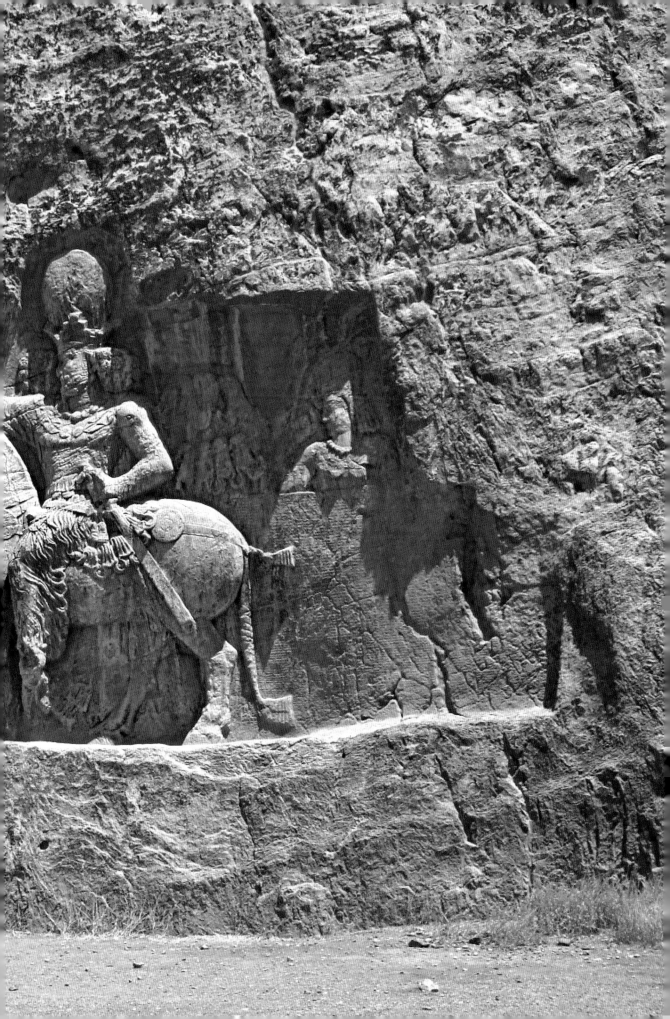

the Great Rift Valley. And Petra, like the entire Middle East, has layers and layers of customs, traditions, and religious backgrounds that make for a rich but often disjointed cultural landscape.

I could see hollowed-out caves and elaborately sculpted porticoes in every direction. I turned to Salam and said in jest, "This place is so surreal that it feels like it is straight out of an *Indiana Jones* movie."

"As a matter of fact, they did use this place in one of the sequels," she said with a chuckle. "But of course you can see why. This is a pretty remarkable place."

After our two-hour walk and a full Middle Eastern meal, we were eager to catch a ride on the most popular means of transportation in Petra—a donkey. Salam flagged down a bedouin named Mustafa, who had skin like aged leather, warm hazel eyes, and eyelashes that could sweep the floor. Each of his donkeys had a more bizarre name than the last. My son Eli's donkey was named James Dean, while mine, strangely enough, was called Michael Jackson. It was my first time on a donkey, and I had never realized that they could canter as fast as a horse. My kids squealed with delight at the sight of me screaming to Mustafa, "Make Michael Jackson stop!" As scared as I was, I was also laughing out loud at the sheer absurdity of my statement.

When we reached a steeper incline, all seven donkeys slowed down, and we got a chance to take in the surroundings. I wanted to pay attention to things as they reached me at that moment—the shifting shadows cast by the setting sun, the pulsating haze, the deepening of the colors of the rocks, the full moon that shone like a cold, white sun over the mountains ahead to the south. A swelling presence arose in me. I looked at Mustafa, who was walking beside me, showing off his crooked smile and his tea-stained teeth. I was struck by how much affection I felt for this man who was almost a stranger. Somehow I felt that he, like all of us, was just trying to fill his life with love.

I marveled at the tapestry of colors and smiled at Phillip and Eli's rollicking laughter, which echoed and filled the canyon with the sound of pure joy. At that moment I had a deep love for life itself and all that it has offered me. It is precisely this expansive feeling that lifts me, that weaves its experience into the texture of my life. And it's places like this, these moments of connection—my proximity to infinite things—that I love above all else in life.

There are enduring motifs, feelings, and landscapes that appear in my personal journey, that give shape to my experience of life. In Petra, it was the vast, hypnotic calm and the crisp dryness of the winter air; the sky suffused with a familiar lilac-gray I knew from back home

Preceding: Persepolis. *Following:* A street by my home in Bel-Air, California. The street is aptly named St. Cloud.

> **❝** *It is precisely this expansive feeling that lifts me,*
> *that weaves its experience into the texture of my life. And it's places like this,*
> *these moments of connection—my proximity to infinite things—*
> *that I love above all else in life.* **❞**

in Iran. It was the sound of my sons' rollicking laughter, taking me back to when I used to hear my brothers' playful banter and games in the alley outside our house. It was the color of the sunlight, the same hues I had often marveled over at dusk from my balcony in Tehran. My visceral response to this landscape in Petra tunneled a path to the trove of childhood memories and was casting light on faces and places that had been long out of reach. We were miles away, yet this was as close as I could get to the country that sheltered me as a child.

As a little girl, I often felt that a sense of belonging was a feeling that should naturally reside within me, whether it was in relation to a country, a specific group, or even a personal identity. But as I rode on that donkey in that blazing desert sun of Petra, it hit me: Belonging is more an act than a feeling. It is actively engaging in a deep level of connection and reciprocity with my feelings, with each individual I meet, each event taking place, or whatever environment I find myself in. The foundations of belonging seem to start on a personal plane rather than on a collective level. And with each successive encounter and moment of connection, my identity expands to encompass seemingly divergent philosophies, whether Eastern or Western; people I never grew up with, from Mustafa the bedouin to Joseph, my safari guide; and landscapes, whether they are the wondrous ruins in Cambodia or the offbeat neighborhoods in Venice, California.

In the end, what is revealed in my travels to other cultures belongs to me forever. What I see and learn becomes a part of me. In Petra, I felt it within me: The truth of my experience lies in the fact that everything is separate unless you see it with an open heart. In my most inspired and unguarded moments, I feel the walls between me and others, me and nature, me and a beautiful melody—crack and disappear. Much like what I encountered in Petra, there is also a narrow passageway that leads you to the interior of something more vast, wondrous, and transcendent. It is when I am in this kind of state that I find myself not in unfamiliar places with unfamiliar faces but, rather, ever so blessed to feel intimate with so many things. It is in these same moments that I feel at home wherever I go—and, most important, at home in my own skin.

✳ ✳ ✳

Left: Younes and Soraya Nazarian (my father- and mother-in-law); *right*: Nasser and Maryam Maddahi (my dad and mom).

Acknowledgments

I am indebted to Martine and Prosper Assouline for their vision, sophistication, and talent. They made the process of publishing this book a real joy, and I am so grateful that it found such a lovely home. Sarah P. Hanson proved to be an extraordinary editor at Assouline Publishing. She immersed herself completely in my story, and her astute remarks fine-tuned the narrative. I want to convey my special gratitude to the talented Camille Dubois and Mathilde Dupuy d'Angeac, who created the most exquisite cover and visually rich layout for my book, and to Perrine Scherrer, for her tireless image research.

Thanks also to my gifted friend and colleague, David Boul, who was one of the first people who recognized that there is a book in my bits and pieces of writing and poetry. His invaluable insight and guidance were indispensable to this book coming together. Tom O'Briant's steadfast support and encouragement, and most of all, his friendship, was invaluable to me. A special thanks goes to Mr. Atta Valizadeh and Mr. Arien Valizadeh for sharing their breathtaking photographs of old and new Iran.

Dr. Carolyn Conger has always been a tremendous source of love, wisdom, and support for me. She is a grand and magical friend and mentor, and I am so very blessed to have her in my life. A heartfelt thanks goes to my dear friend Elizabeth Mossanen, who with her generous ways planted the seeds of writing this book. I truly cherish our friendship and deep bond.

No acknowledgement would be complete without recognizing the special role my family has played in bringing this memoir to life. My beloved parents, Maryam and Nasser Maddahi, instilled a love of learning and growth that is evident in all their kids. Their sacrifices to make a better life for their family will never be forgotten. My siblings have played a big role in my life, oftentimes serving as my surrogate parents, protectors, and models of the kind of adult I wanted to aspire to be. Jamshid and Angela, Lida and Behrouz, Dariush and Mojgan, and Kourosh and Nazi have a special place in my heart. Natasha and Jonathon, you are like my two younger siblings. And of course, I have tremendous love for all my other nieces and nephews who have been so generous with their emotional support in this project. A million thanks to my Uncle Nasser for sharing his intimate knowledge of the calamities of postrevolutionary Iran. And I am indebted to the hours that Mitra and Molouk spent in finding family photos and archival material for the book.

I want to express my special appreciation to Soraya and Younes Nazarian. Their attentiveness, sensitivity, and love for me make them the kind of in-laws I always dreamed of. I am profoundly proud and happy to have Sam, Sharon, Sharyar, and Shula in my life. They have always been my cheerleaders.

I am infinitely grateful for the unconditional support and encouragement of my dear husband, David. He has been a shining light in my life and his love for me has opened worlds upon worlds for me.

My sons, Phillip and Eli, are my two true blessings and the "noor" of my eyes. If my story contributes to a deeper understanding of their mom and their own family roots, then I am glad to say that this book has more than met my intended purpose.

IMAGE CREDITS

Endpages: © Arien Valizadeh.

P. 4: © All rights reserved; p. 6–7: From family archives of Angella M. Nazarian; p. 8, 11: Photo by William Mc Quitty, © All rights reserved; p. 12, 14: From family archives of Angella M. Nazarian; p. 20: Photo by Angella M. Nazarian; p. 24: © Robert W. Kelley/Time Life Pictures/Getty Images (top left), © Imperial Iranian Archives/Topham/The Image Works (top right and bottom left), © Raymond Depardon/Magnum Photos (center right), © Cyrille Boulay Collection (bottom right); p. 25: © James L. Stanfield/National Geographic/Getty Images; p. 26: © Werner Forman Archive/Archaeological Museum, Tehran; p. 29: From family archives of Angella M. Nazarian; p. 30: Photo by Mahmoud Pakzad, © Behnaz Pakzad; p. 32: Photo by William McQuitty, © All rights reserved; p. 34: From family archives of Angella M. Nazarian; p. 37: Photo by Angella M. Nazarian; p. 39: © Arien Valizadeh; p. 40: © All rights reserved; p. 43: © Kaveh Kazemi/Getty Images; p. 48: © Hossein Nilchian/Silk Road Gallery; p. 52–53: © All rights reserved (top), © Arien Valizadeh (bottom); p. 55: © Miros Valipour; p. 59: © Shirin Neshat, Courtesy Gladstone Gallery; p. 64–65: © Silvia Morara/Corbis; p. 66, 69: Photo by Angella M. Nazarian; p. 72–73: © Roger Wood/Corbis; p. 75, 77: Photo by Angella M. Nazarian; p. 80–81: © *The Jewish Journal of Greater Los Angeles*, www.jewishjournal.com; p. 84: © Shadi Ghadirian, Courtesy Silk Road Gallery; p. 91: © Arien Valizadeh; p. 93: © Miros Valipour; p. 94: Photo by Angella M. Nazarian; p. 98: © Arien Valizadeh; p. 100, 101: © Shirin Neshat, Courtesy Gladstone Gallery; p. 104: © Vanni Archive/Corbis; p. 109: © Abbas/Magnum Photos; p. 112: © Shirin Neshat, Courtesy Gladstone Gallery; p. 115: From family archives of Angella M. Nazarian; p. 116: © Arien Valizadeh; p. 118: © Bruno Barbey/Magnum Photos; p. 121: © Miros Valipour; p. 122: © Arien Valizadeh; p. 130: Photo by Angella M. Nazarian; p. 134–135: © Arien Valizadeh; p. 136: © All rights reserved; p. 139: Photo by Angella M. Nazarian; p. 142: © Wellcome Library, London; p. 146, 147: Photo by Angella M. Nazarian; p. 151: © Miros Valipour; p. 156: Photo by Angella M. Nazarian; p. 159: Photo by Katya Kallsen, © President and Fellows of Harvard College; p. 160–161: © Arien Valizadeh; p. 164–165: Photo by Angella M. Nazarian; p. 166: From family archives of Angella M. Nazarian.

* * *

The publishers would like to thank: Jessica Almonte and Lorraine Goonan (The Image Works), Cyrille Boulay, Rachael Cross (The Wellcome Trust), Rob Eshman and Lynn Pelkey (*The Jewish Journal*), Kiarash Ghavidel Firooz (Silk Road Gallery), Themis Halvantzi (Werner Forman Archive), Dilcia Johnson (Corbis), Christopher Linnane (Harvard Art Museum), Shirin Neshat, Eric Nylund (Gladstone Gallery), Maryam and Nasser Ovissi, Michael Shulman (Magnum Photos), Miros Valipour, Arien Valizadeh, and Kirsten Winfield and Stephanie Miller (Getty Images).

* * *

Editor's note: Lonesome George, the Galapagos tortoise, has now successfully mated.